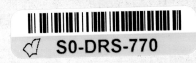

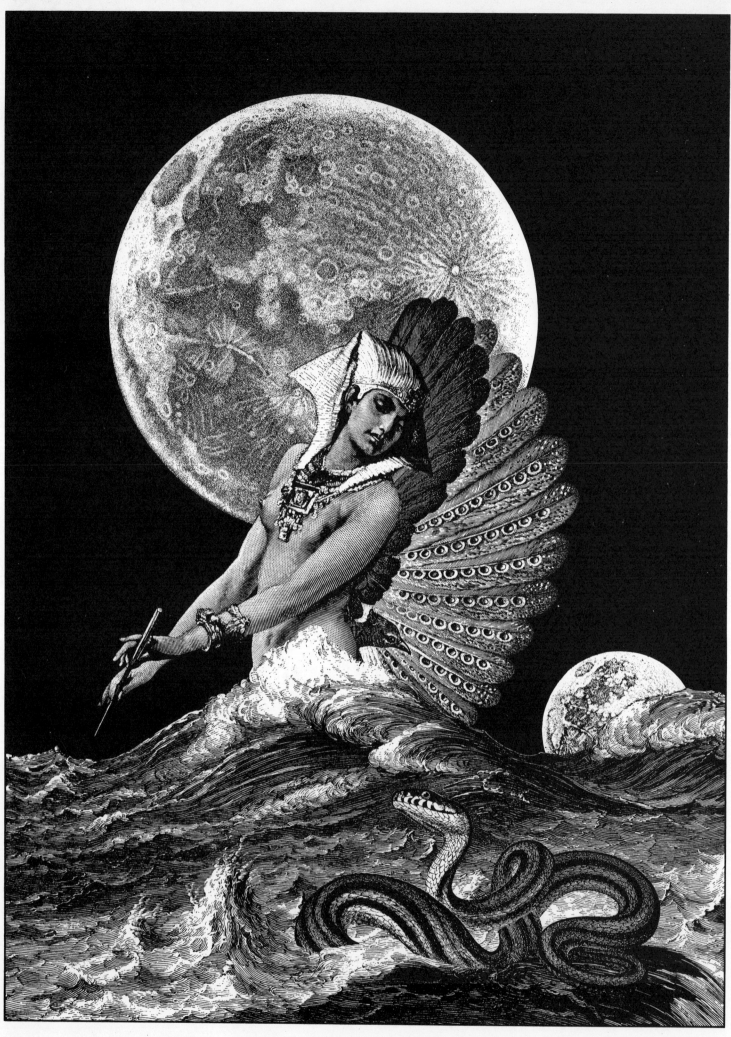

"Labysminia" by David Singer, a collage composed entirely of images from this book.

HARTER'S PICTURE ARCHIVE FOR COLLAGE AND ILLUSTRATION

OVER 300 19TH-CENTURY CUTS

edited by

Jim Harter

Dover Publications, Inc.
New York

Published in Canada by General Publishing Company, Ltd., 30 Lesmill Road, Don Mills, Toronto, Ontario.

Published in the United Kingdom by Constable and Company, Ltd., 10 Orange Street, London WC2H 7EG.

Harter's Picture Archive for Collage and Illustration is a new work, first published by Dover Publications, Inc., in 1978.

DOVER *Pictorial Archive* SERIES

International Standard Book Number: 0-486-23659-5
Library of Congress Catalog Card Number: 78-54868

Manufactured in the United States of America
Dover Publications, Inc.
180 Varick Street
New York, N.Y. 10014

INTRODUCTION

Collage is the art of gathering images from a variety of sources and pasting them down into a single creative work. It combines a craft-like simplicity of materials and execution with a dynamic potential for visual impact and symbolic expression. A highly accessible contemporary art form, it is popular among professional artists and talented amateurs alike.

The birth of collage as a serious medium took place during the early 1900's in France. Around this time, the two Cubist painters Pablo Picasso and Georges Braque started to incorporate newsprint, cigarette wrappers, wallpaper and other decorative materials into their paintings to achieve textural variations. Later on, Dadaists like Kurt Schwitters and Marcel Duchamp began to create pictures entirely out of such materials, which they cut out and glued upon a background of canvas or wood. The traditional name of painting seeming inappropriate for this new art, the term collage—from the French verb *coller,* "to glue"—came into use.

Soon after these initial experiments in collage, the early Surrealists, notably Max Ernst, began to use for their collages contemporary photographic images and wood engravings they found in periodicals, books and newspapers. Drawing upon such intellectual energies of the day as Freud's theories and Jung's concept of the collective unconscious, and reflecting the rapidly growing threat of domination of man by the machine, the strongly symbolic visual language of collage was transferred into a vital medium for serious social and personal statement. Ernst, and in more recent years other artists, including Wilfried Sätty and Anita Siegel, using conventional pictures in unconventional arrangements, created fantastic tableaux that commented upon the absurdity and tensions of modern society.

By the early 1900's, as photographic (halftone) reproduction became feasible in commercial printing, the use of line engravings was discontinued. Thus, today many other materials are being used in the construction of collages. As lively and flexible as these new materials are, the use of line engravings still offers unique textural dimensions more in line with the origins of the form. Engravings have a dreamlike quality that other materials cannot duplicate. Also, the variations in the engraver's lines from one image to another create very interesting blending and shading effects in the finished works. The six collages reproduced here display a few of the many qualities made possible by engravings.

As mentioned earlier, collage is basically craft-like in its materials and techniques. Aside from the actual pictures used, the collage artist need concern himself with only two items: a cutting tool (or tools) and glue. (Pen, ink and white paint may also be required, depending upon the amount of embellishment desired.) There are two kinds of cutting tools: small manicure scissors and a single-edged razor

blade or small X-ACTO knife (#16 blade). Some people prefer a scissors for tiny curves, while others—myself included—feel more confident with the greater precision afforded by the blade or knife. Often the material from which the images are cut determines the proper cutting tool.

Of the dozens of glues on the market, rubber cement (the one- or two-coat formula) and vegetable-base glues similar to the kind used on postage stamps seem to be the most effective for collage. Neither of these glues will stain, tear or obliterate any part of the work, as casein or synthetic glues often do. Both of the recommended glues also have great longevity, are easy to work with and leave the surface of the collage free of irregularities. (Rubber cement does require a thinner to achieve the proper consistency and a special eraser or "pickup" to remove any excess without damage to the work itself.)

Once the essential materials are assembled, the actual methods of choosing the images and putting them together into collages are as numerous as the artists themselves. Some people begin with a set theme or concept, then select images that best express it. Titles are particularly important to this method because they provide a concise synopsis of the collage's significance. Some artists rely upon the individual graphic or symbolic qualities of the images themselves to suggest a pattern or general layout for the collage. Archetypical images dealing with time, the elemental powers of nature, animals and sexuality are useful sources of inspiration for this method.

Once the images are selected and some sense of the collage is formulated, there are many directions in which the artist can go. Of course the least complicated and most traditional is the pasting down of the original engravings themselves into the finished collage. This is the method displayed in "Lyrehc," by Don Evans. This collage, made up entirely from elements in this book, consists of several dominant images, each of which is a combination of a number of smaller images cut to fit together as in a jigsaw puzzle, then glued into place.

The technique displayed by the other five collages included here begins where "Lyrehc" leaves off. After the collage is assembled as described above, an enlarged photoprint is made of it, often at over 200% of its original size. In this way, the full detail of each image as well as the quality of the engraver's lines become dramatic parts of the work. Then, using pen, ink and white paint, the artist can clean imperfections in the lines, blend them together, outline figures or shade areas, as desired. For example, in Sätty's "Lady of the Wind" nearly all the texture work of the waves and waterfalls surrounding the dark woman in the center was done with pen and ink. In "The Dream Machine" I lengthened the lines of the upper left-hand corner of the projectionist image to change a rounded corner into a square one, and also outlined the woman's face.

Not only can this photoprinting procedure result in very innovative effects, but it can also save the artist a great deal of painstaking work. Size no longer becomes an obstacle when looking for the right images because any image can be enlarged or reduced to the desired proportions. A good illustration of the amount of work this method can save is "The Theatre of Void." I began by pasting down the left half of the collage reproduced here, using a mirror as I went along to get an idea of how the completed work would look when I had completed the left-hand side. I had an enlarged photoprint made, reversed the negative and printed a mirror image of it. I pasted both prints down adjoining each other and smoothed over the joint with pen and ink. Without this method, this collage would have been extremely difficult, if not impossible, to do.

These methods are only two of the many possible techniques using the material from this book. There are over 300 engravings in this collection, all selected from periodicals, books and catalogues dating mostly from 1870 to 1900. They are sharply defined and clearly printed on one side of each page to allow for optimal use of their lines and textures and to eliminate the possibility of "show-through." I have attempted to include rare pictures of relics, rituals, people, animals, geometric shapes and designs of a greater variety than readily available elsewhere. Also, there are 25 full-page scenes of historic, natural and city vistas that can serve as backgrounds for collages. Other sources of engravings of similar breadth and rarity include Gillon's *Picture Sourcebook for Collage and Decoupage* (Dover, 1974) and many of the other books in the Dover Pictorial Archive Series.

JIM HARTER

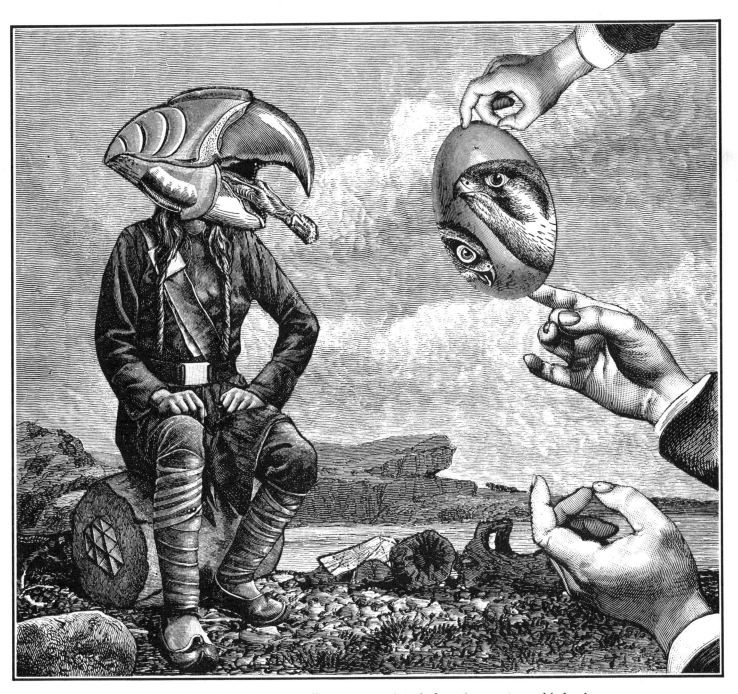

"Lyrehc" by Don Evans, a collage composed entirely of images from this book.

"The Theatre of Void" by Jim Harter, a collage composed entirely of images from this book.

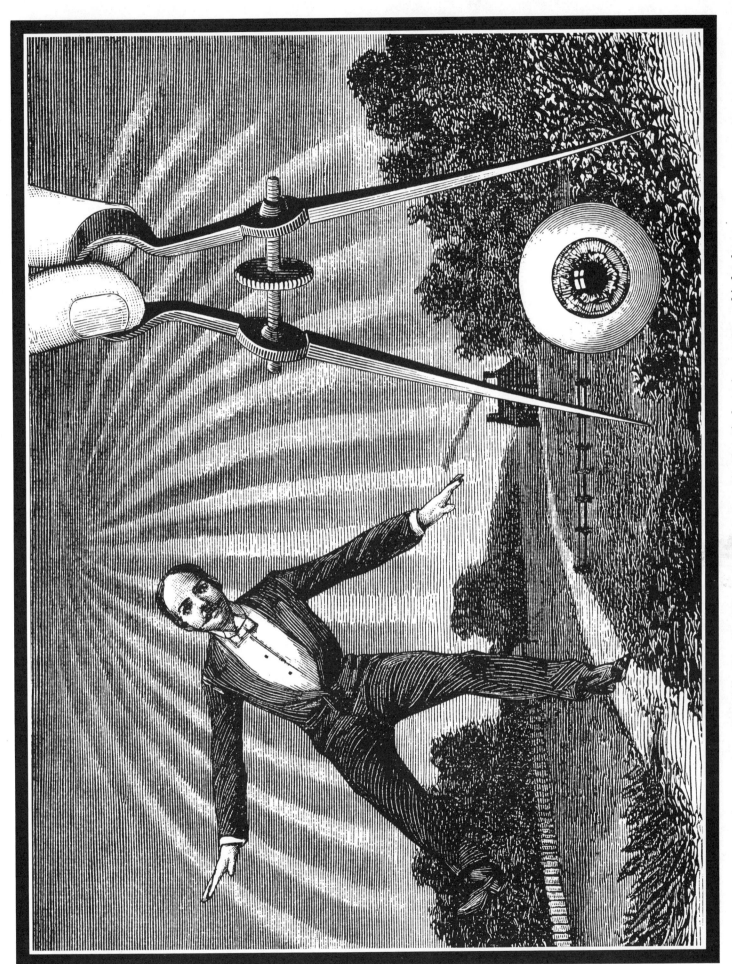

"Life Line" by Jim Harter, a collage composed entirely of images from this book.

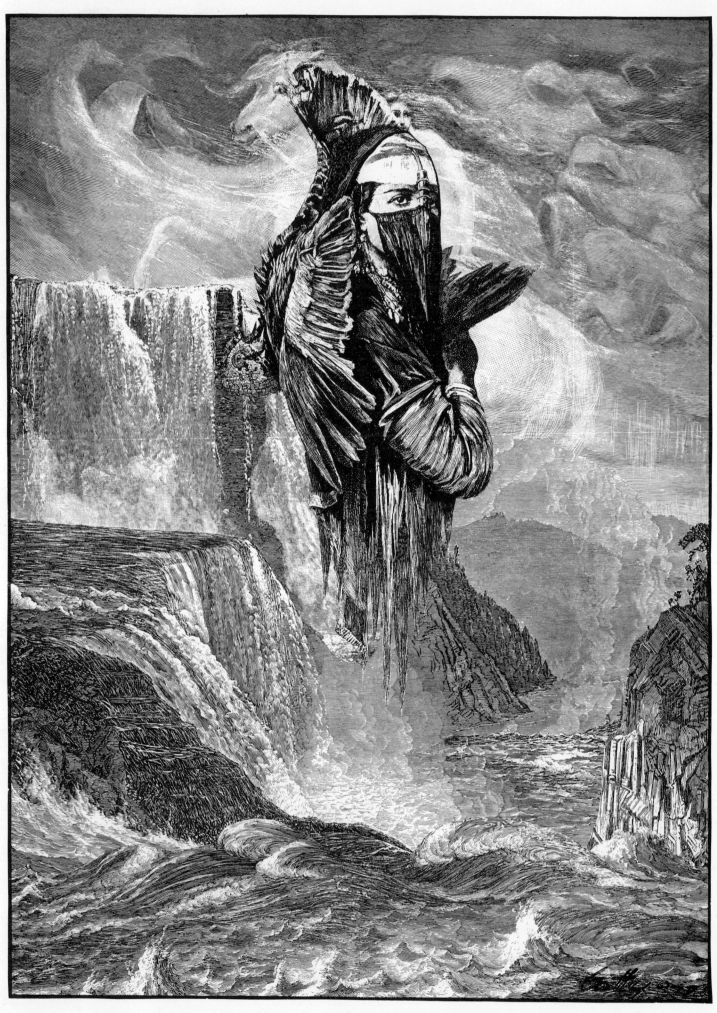

"Lady of the Wind" by Wilfried Sätty, *a collage composed entirely of images from this book.*

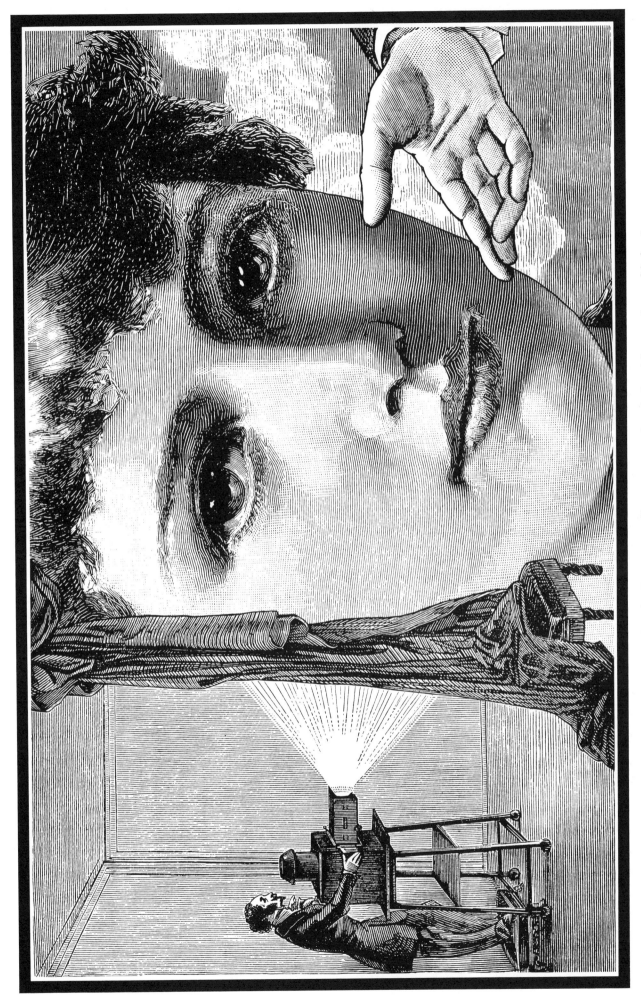

"The Dream Machine" by Jim Harter, a collage composed entirely of images from this book.

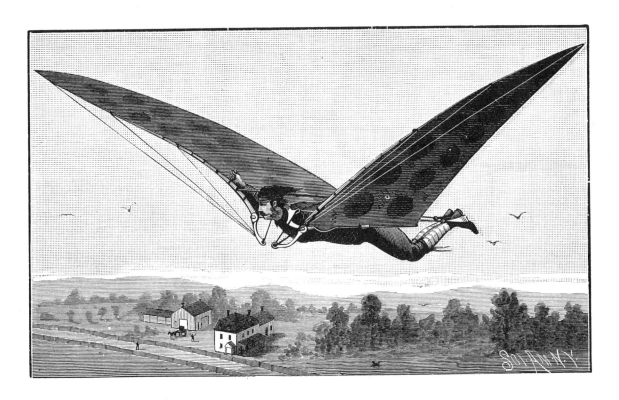

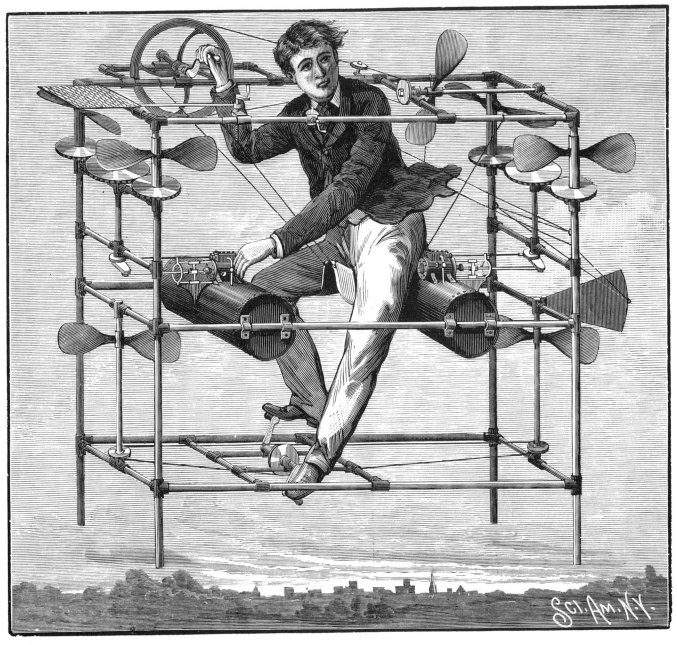

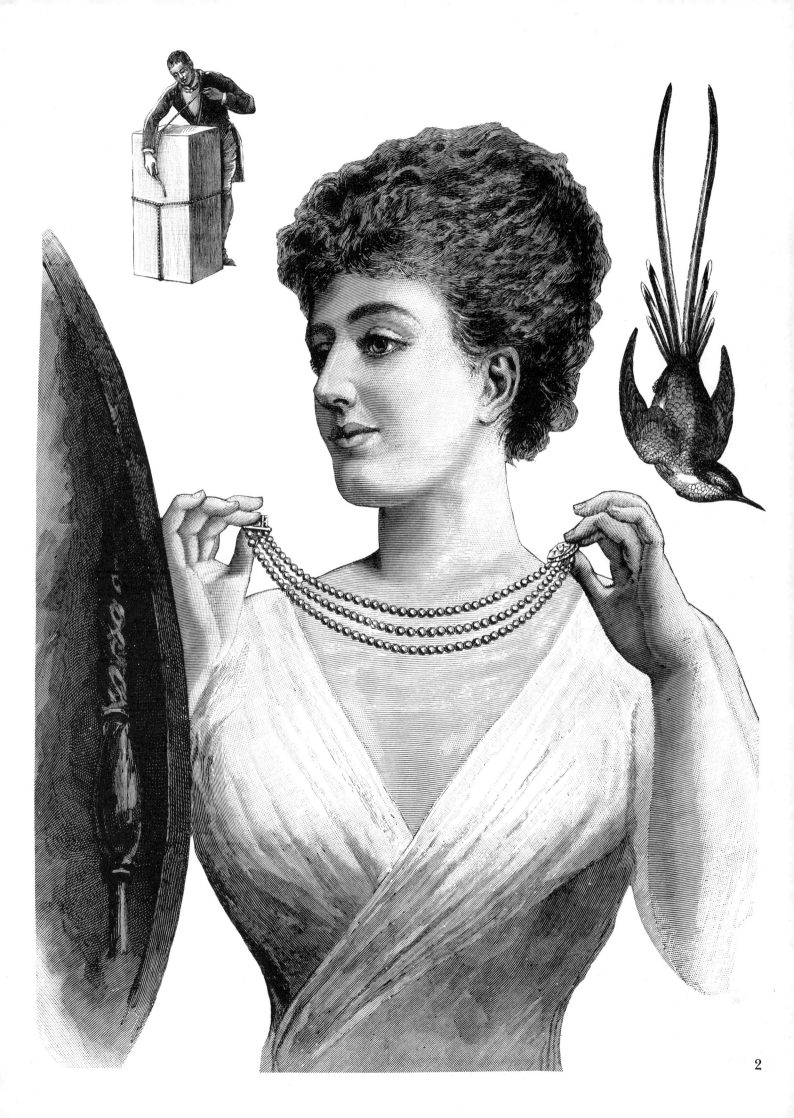

2

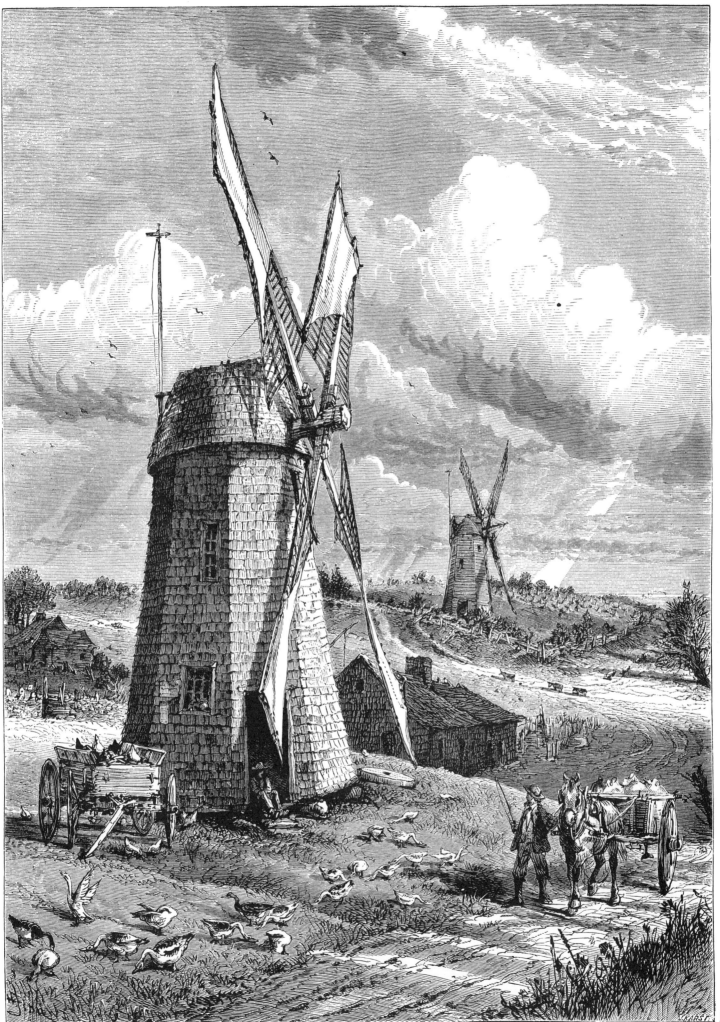

3

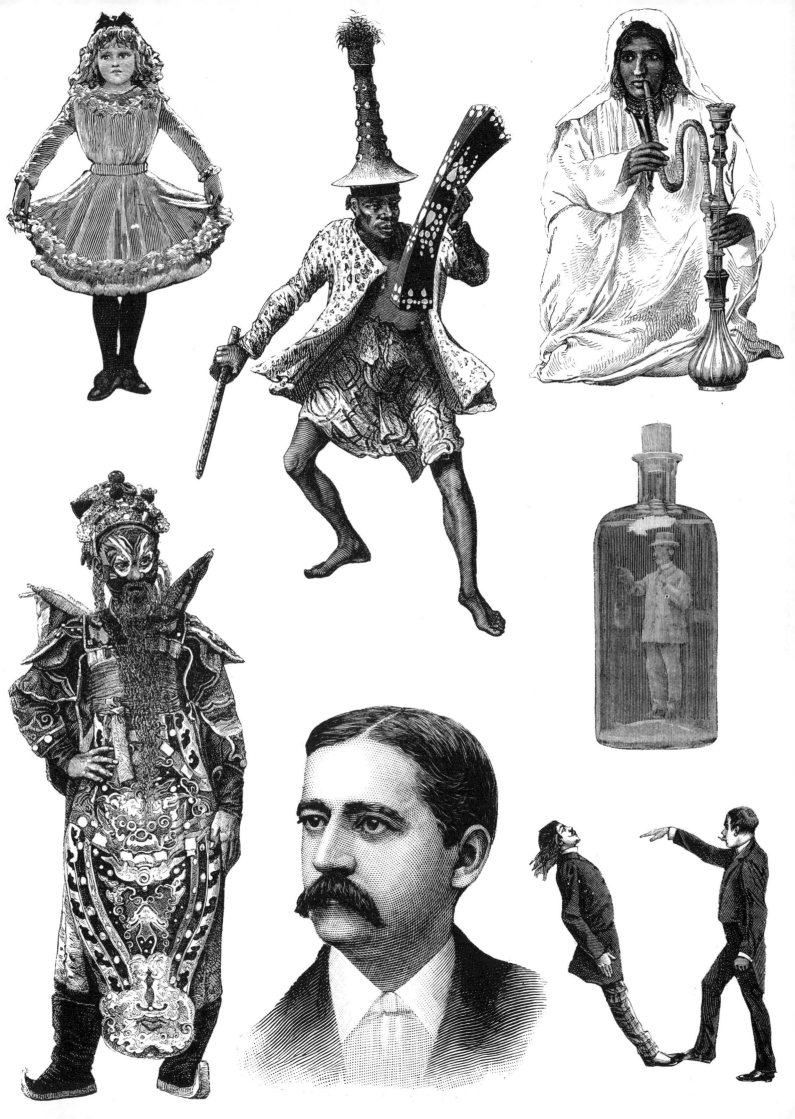

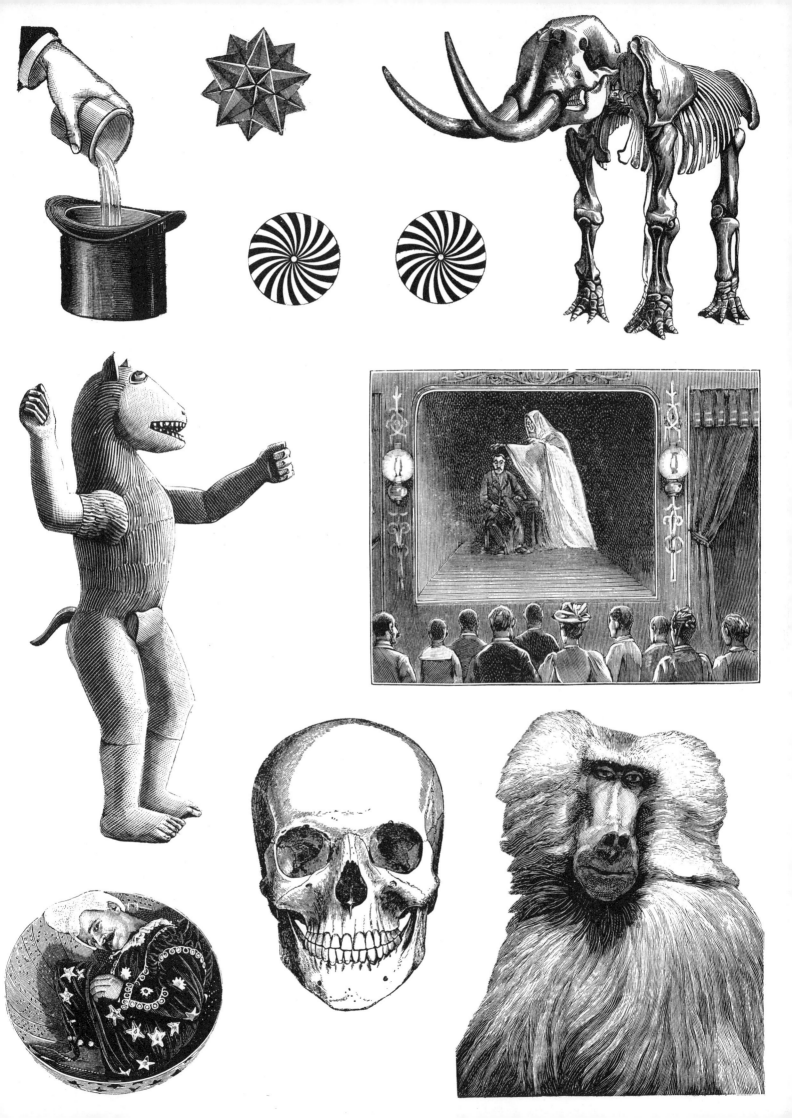

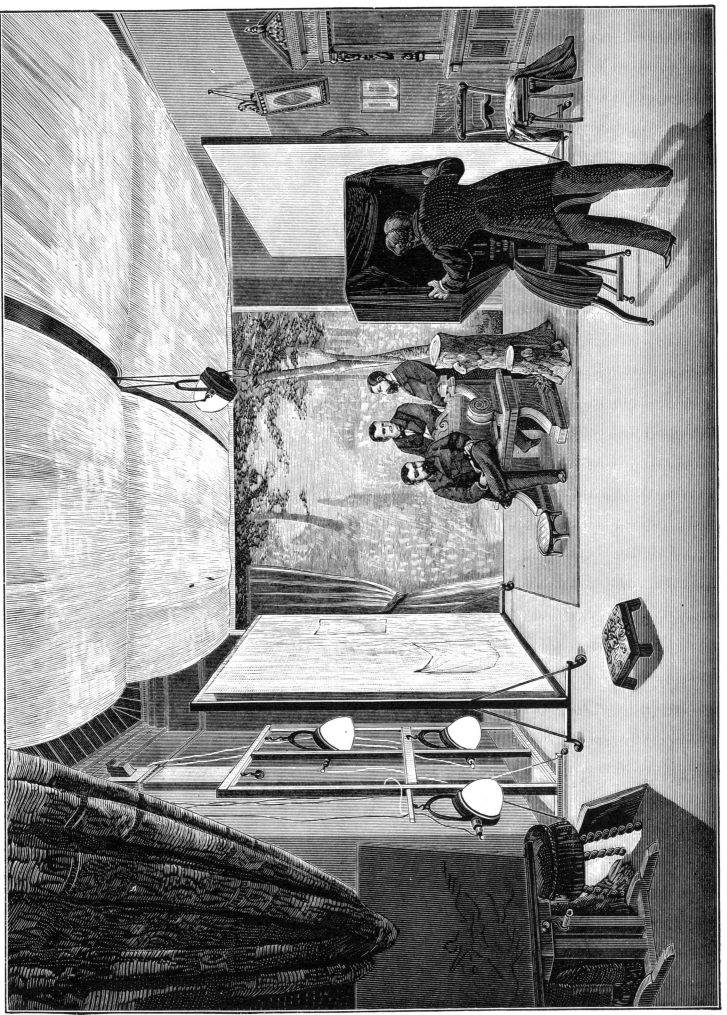

6

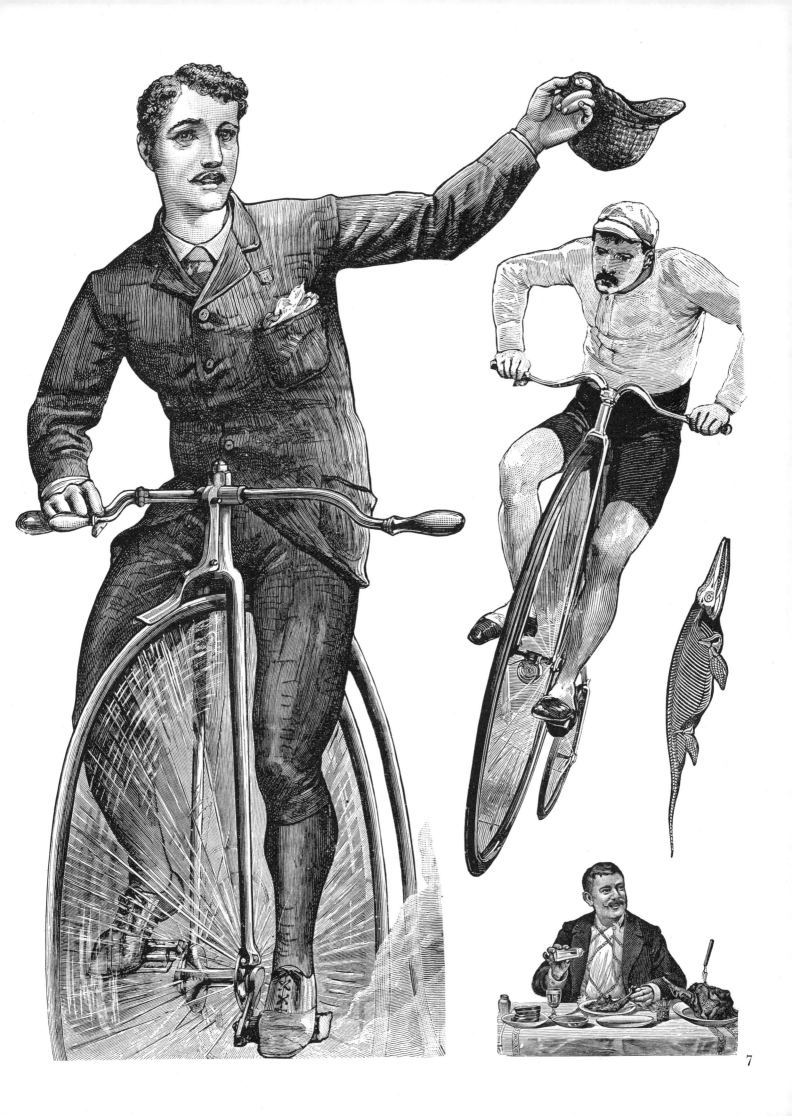

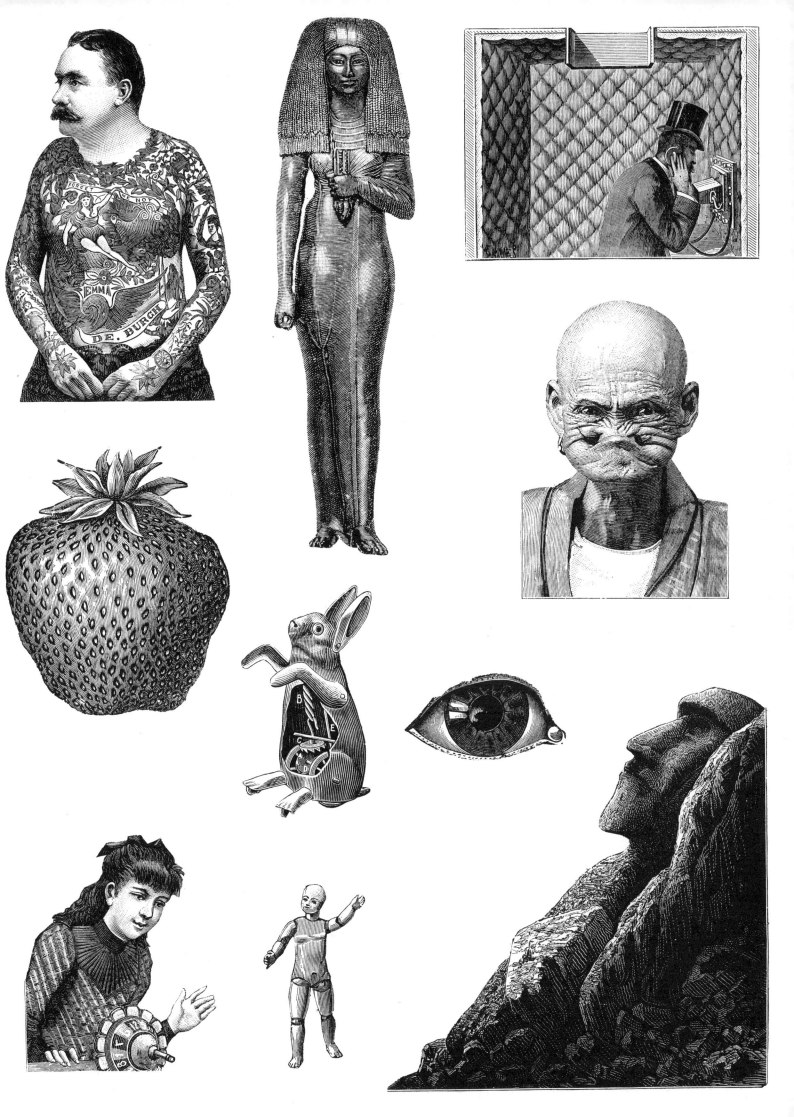

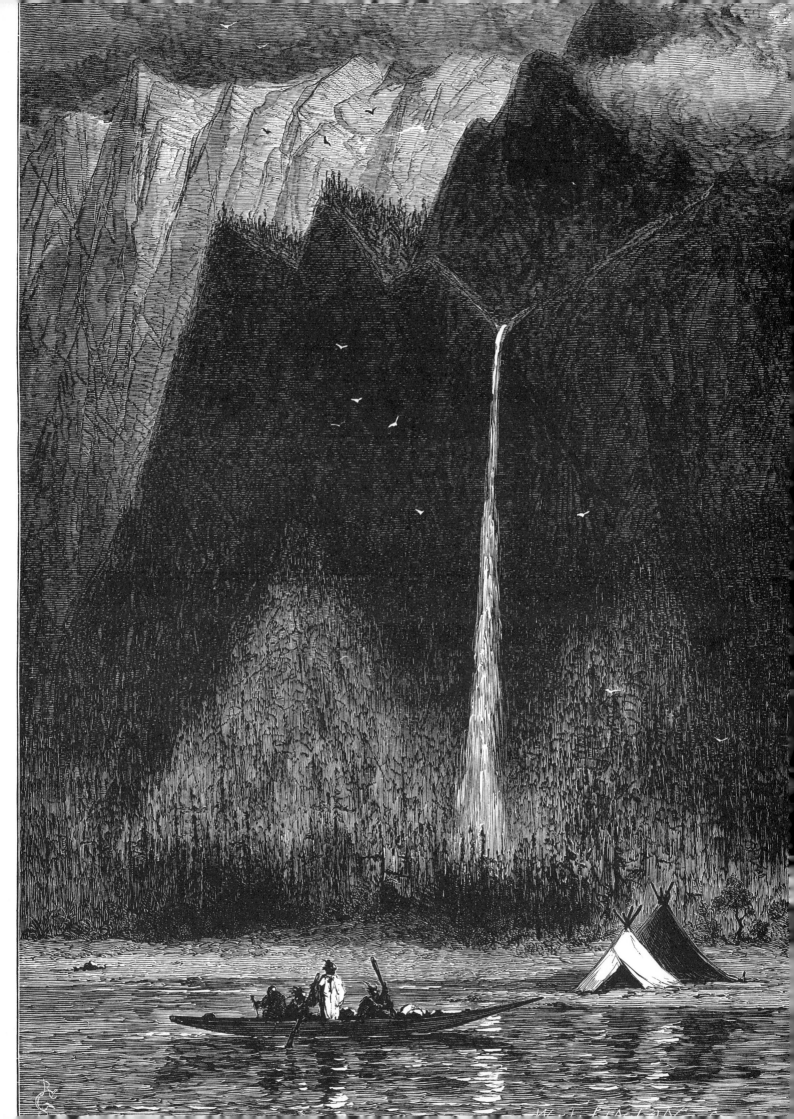

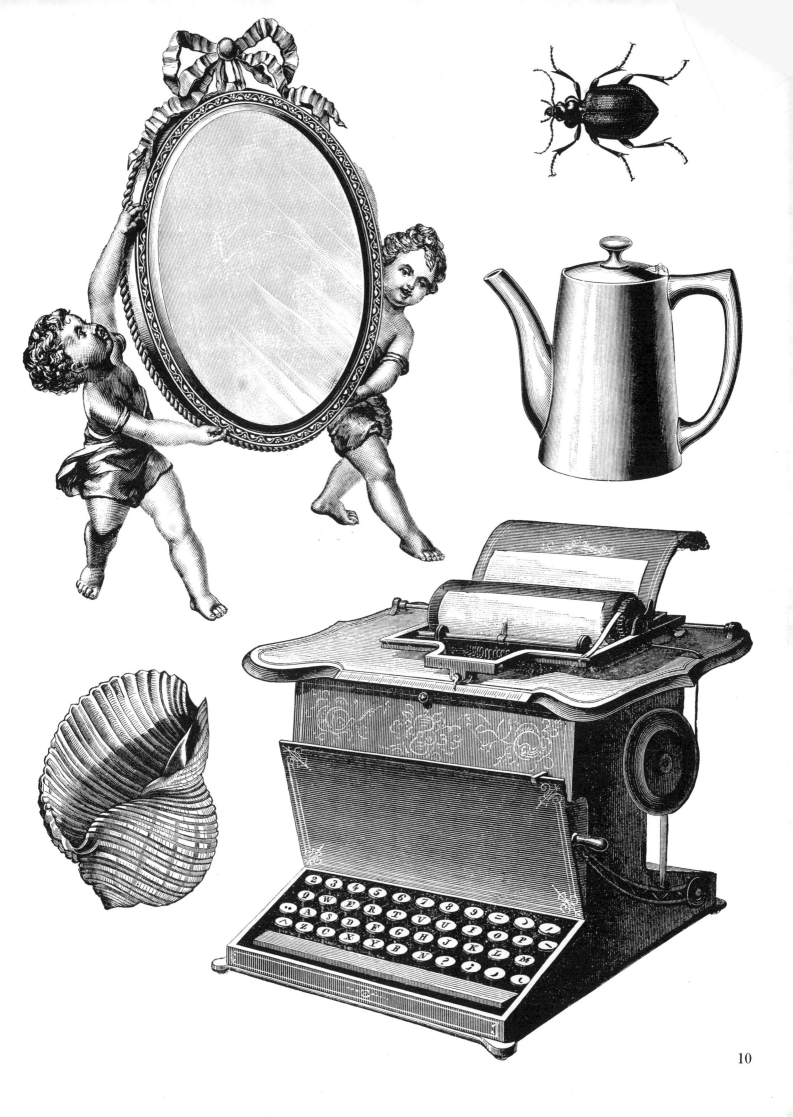

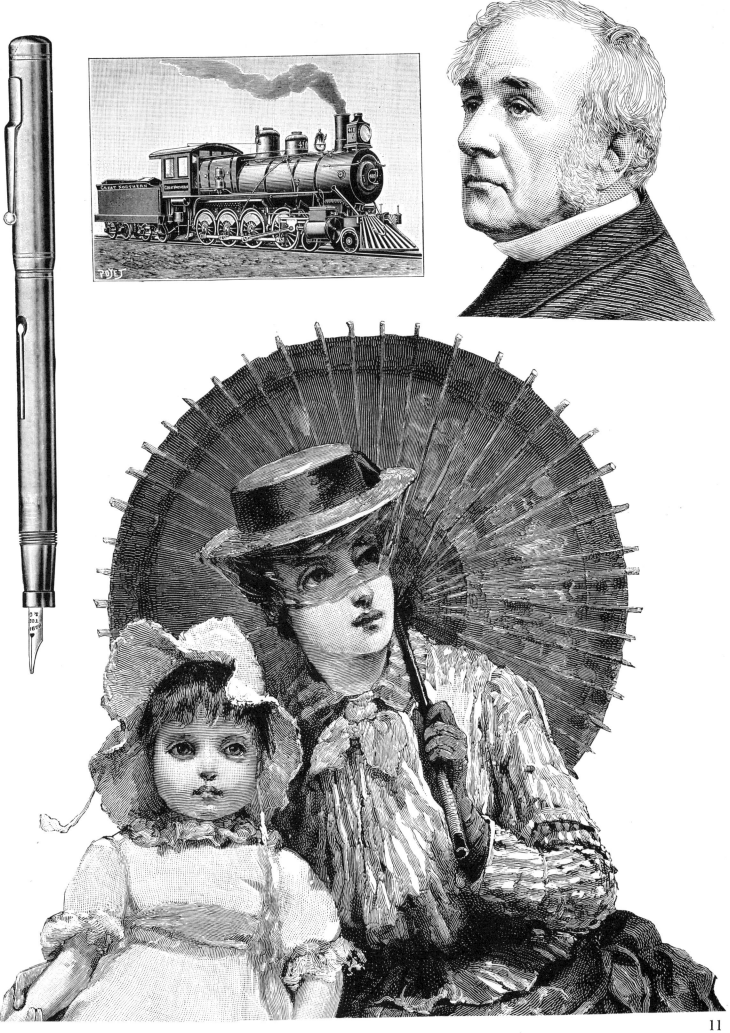

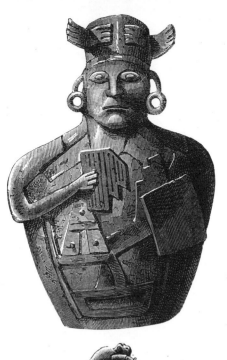

Willenberg & Sorber St.

12

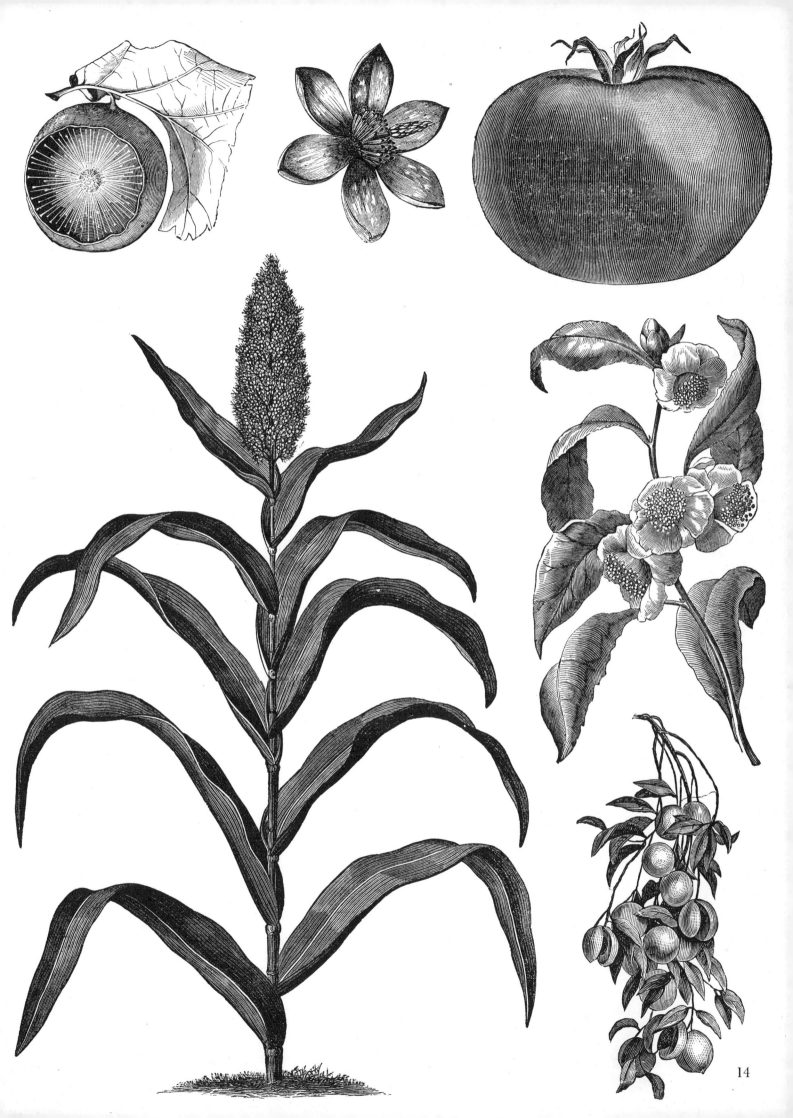

14

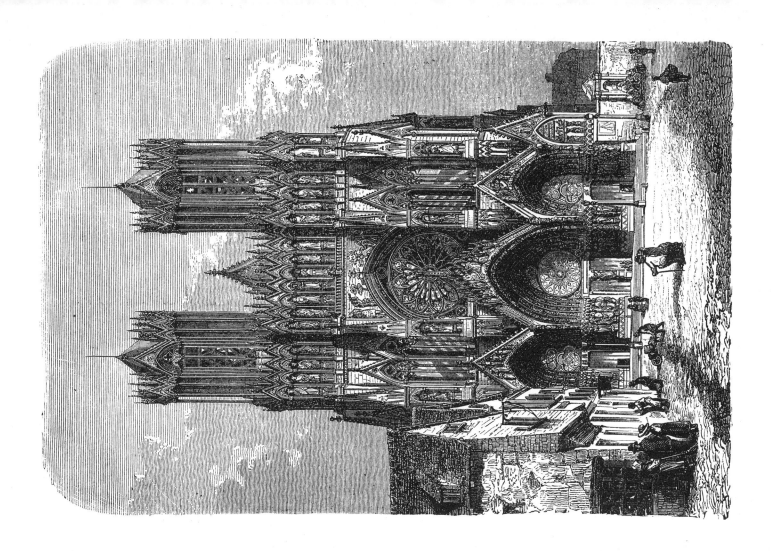

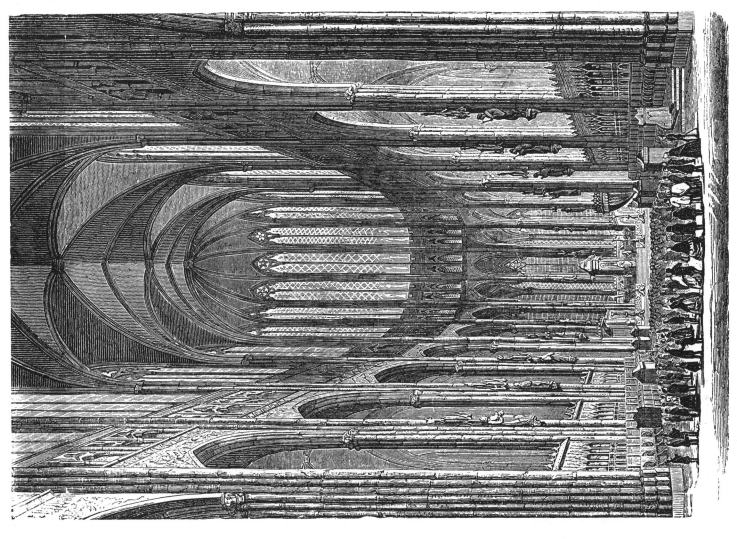

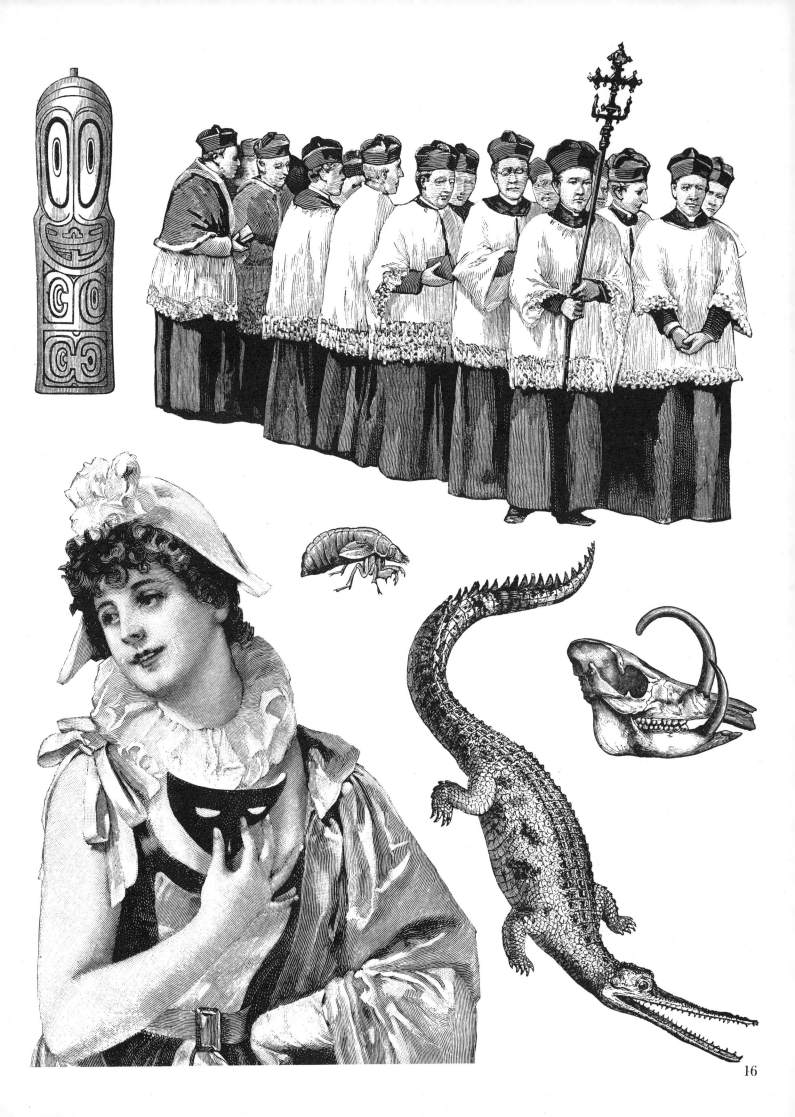

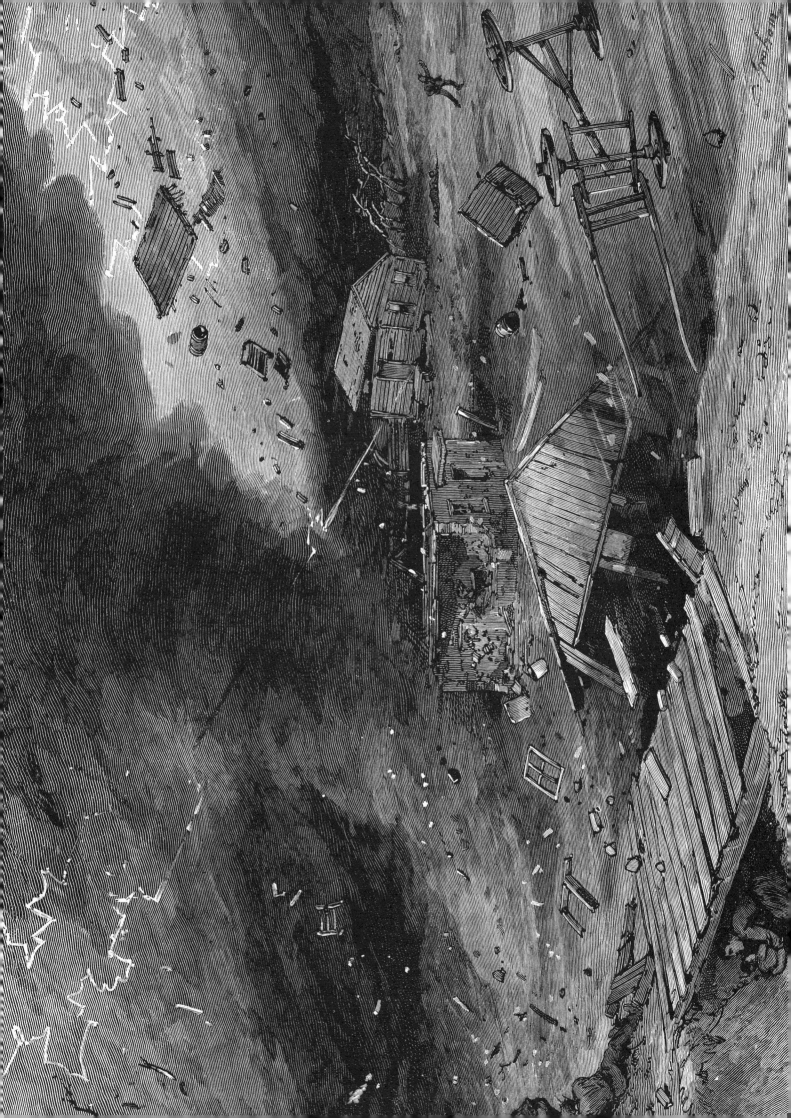

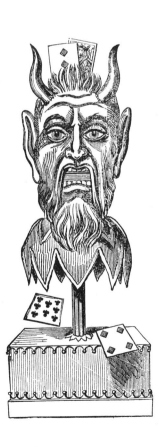

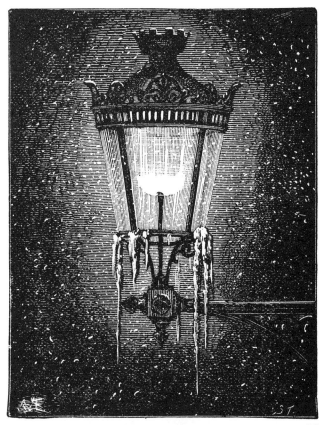

19

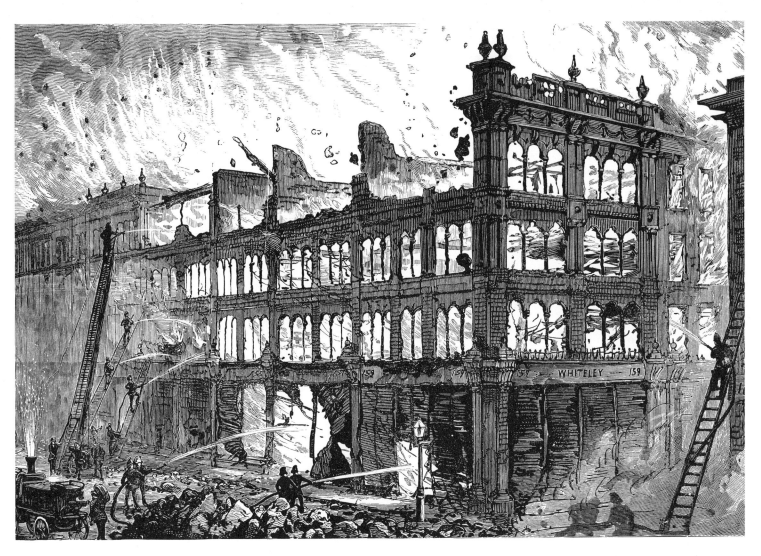

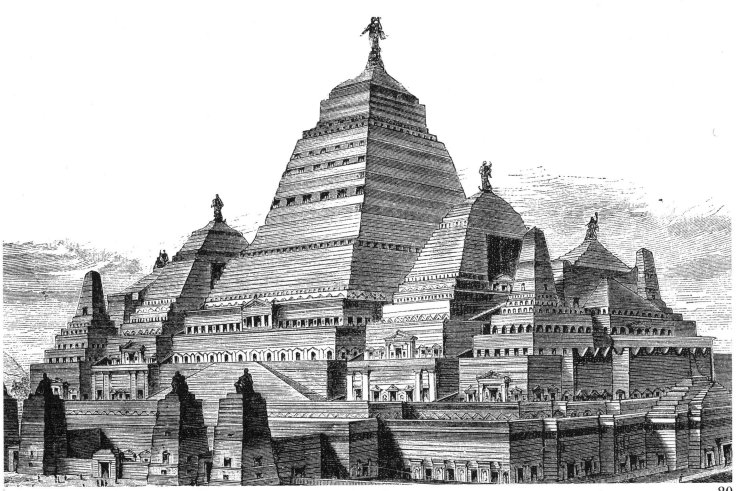

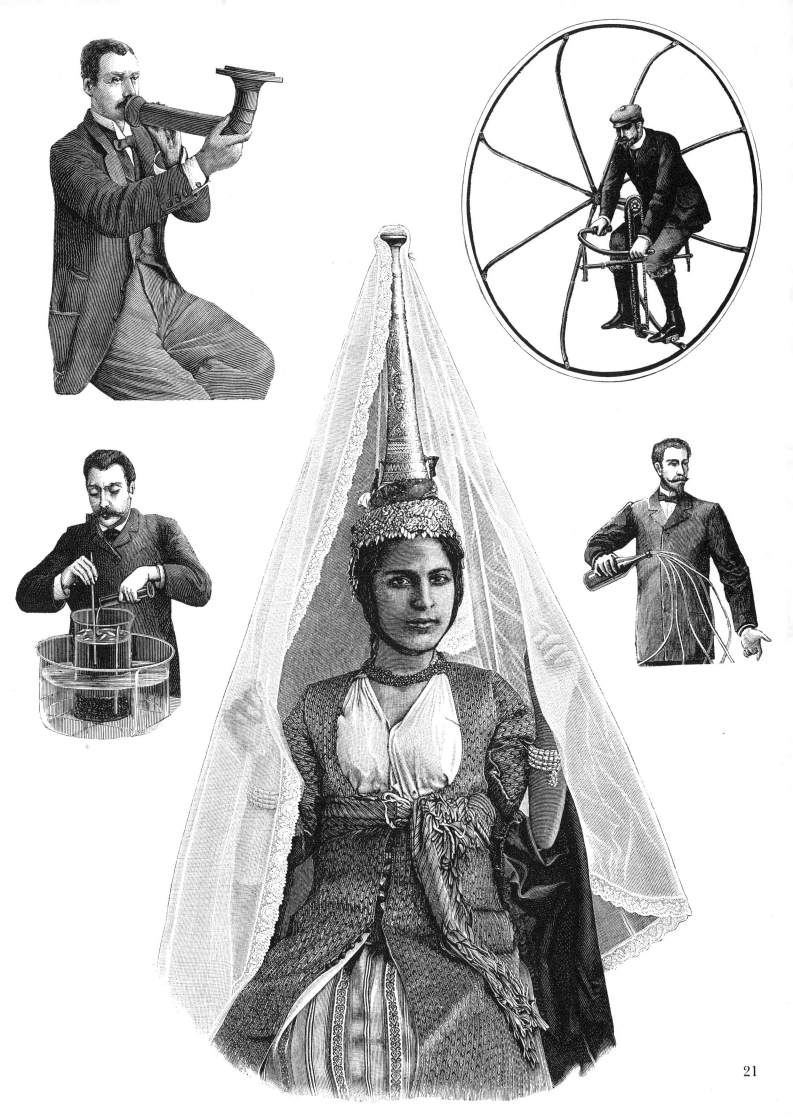

21

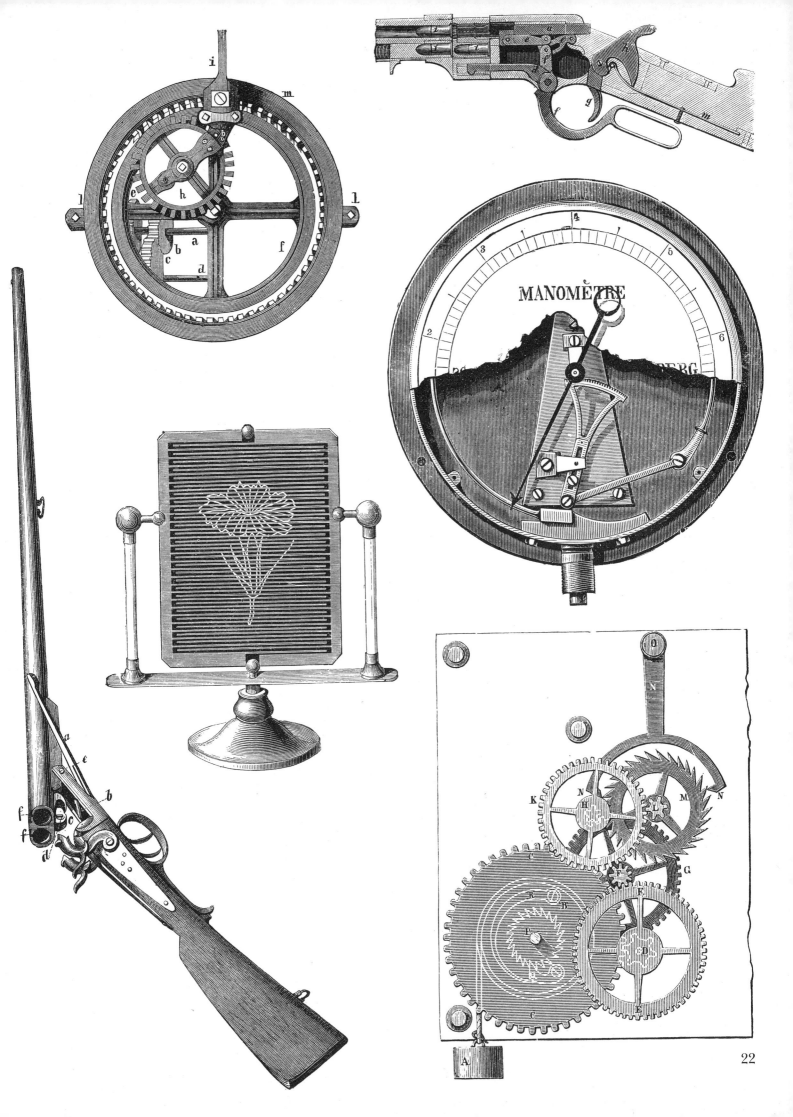

MANOMÈTRE

22

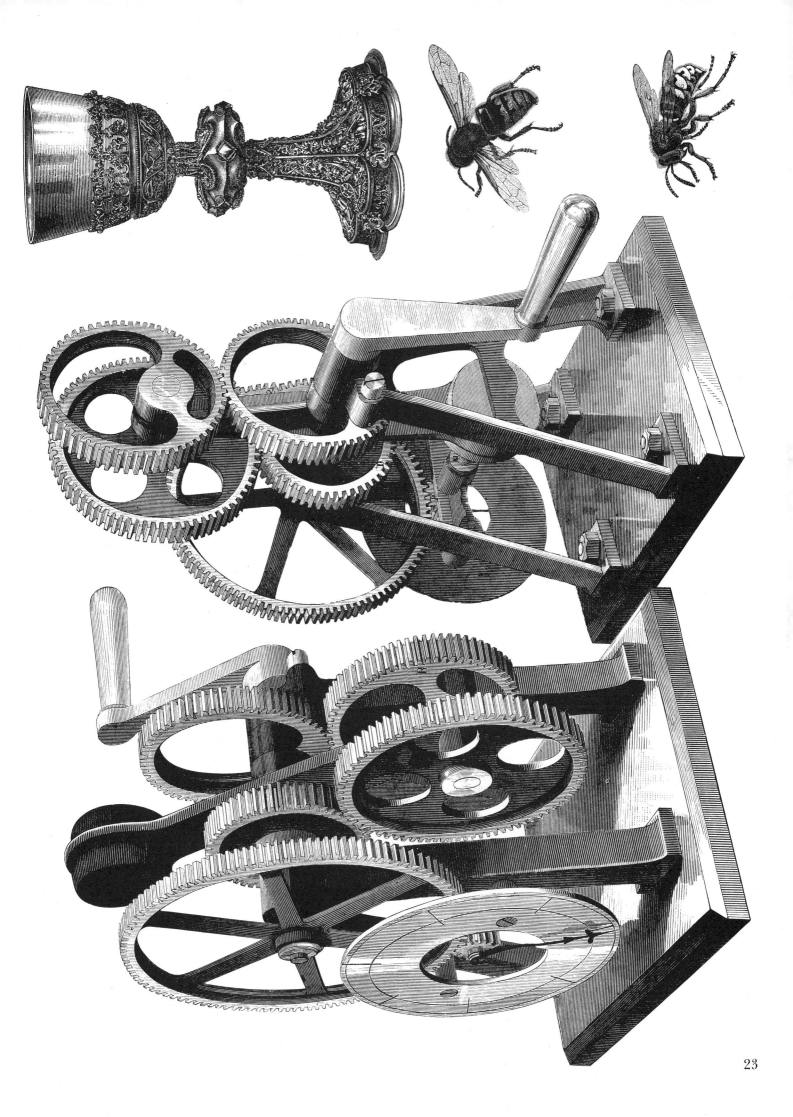

23

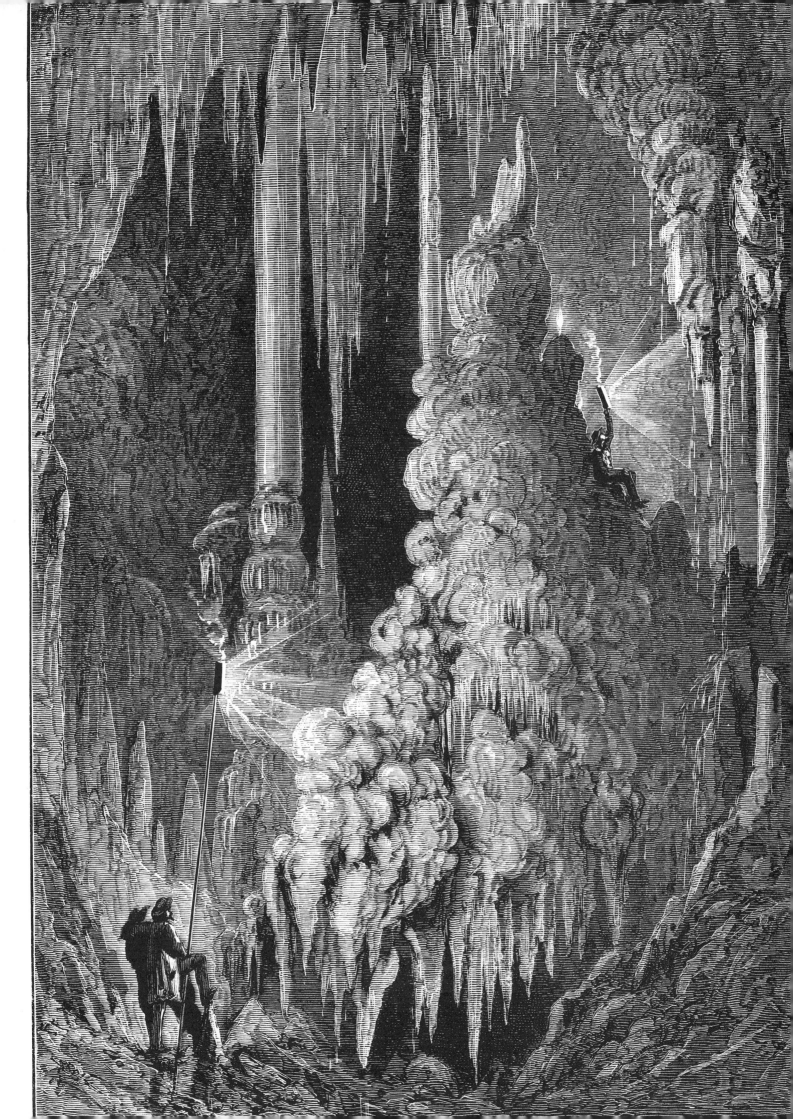

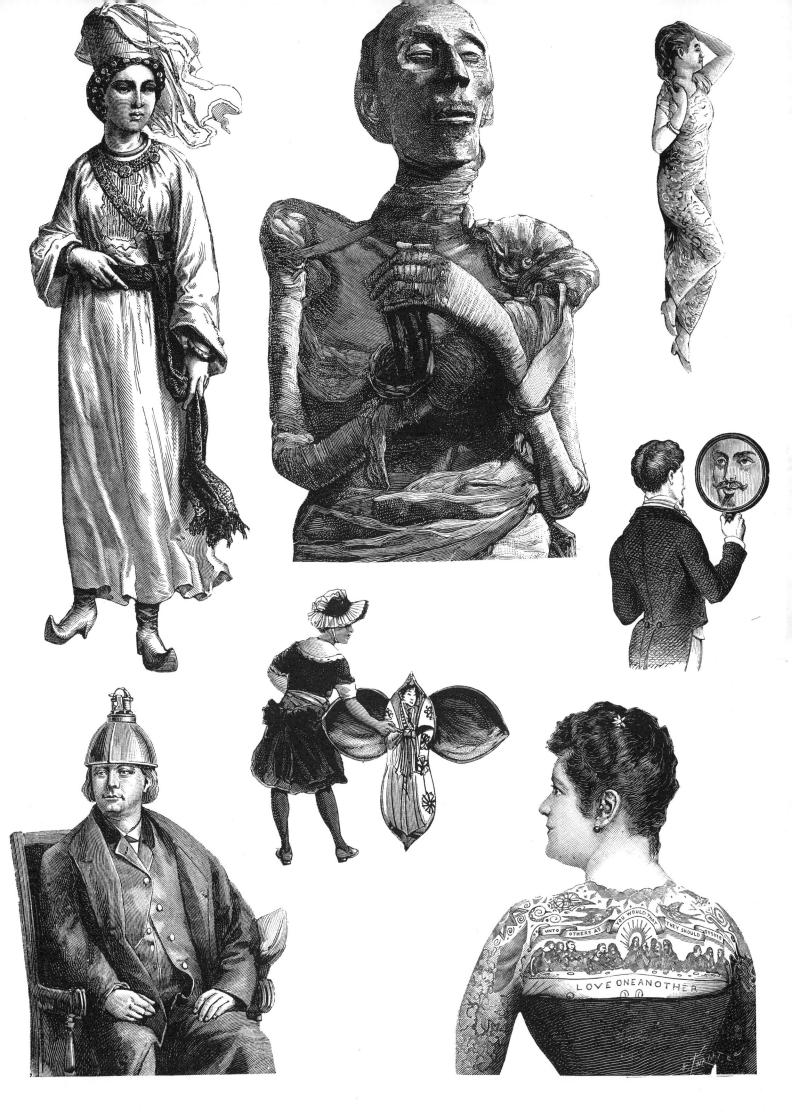

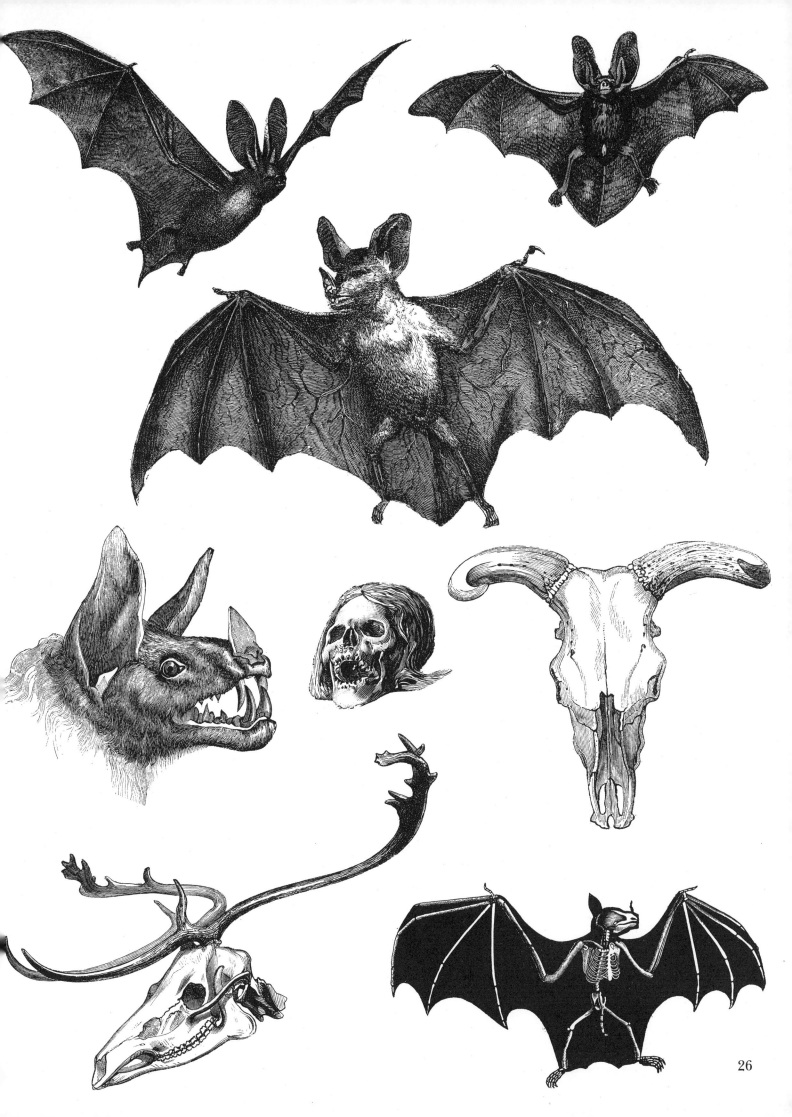

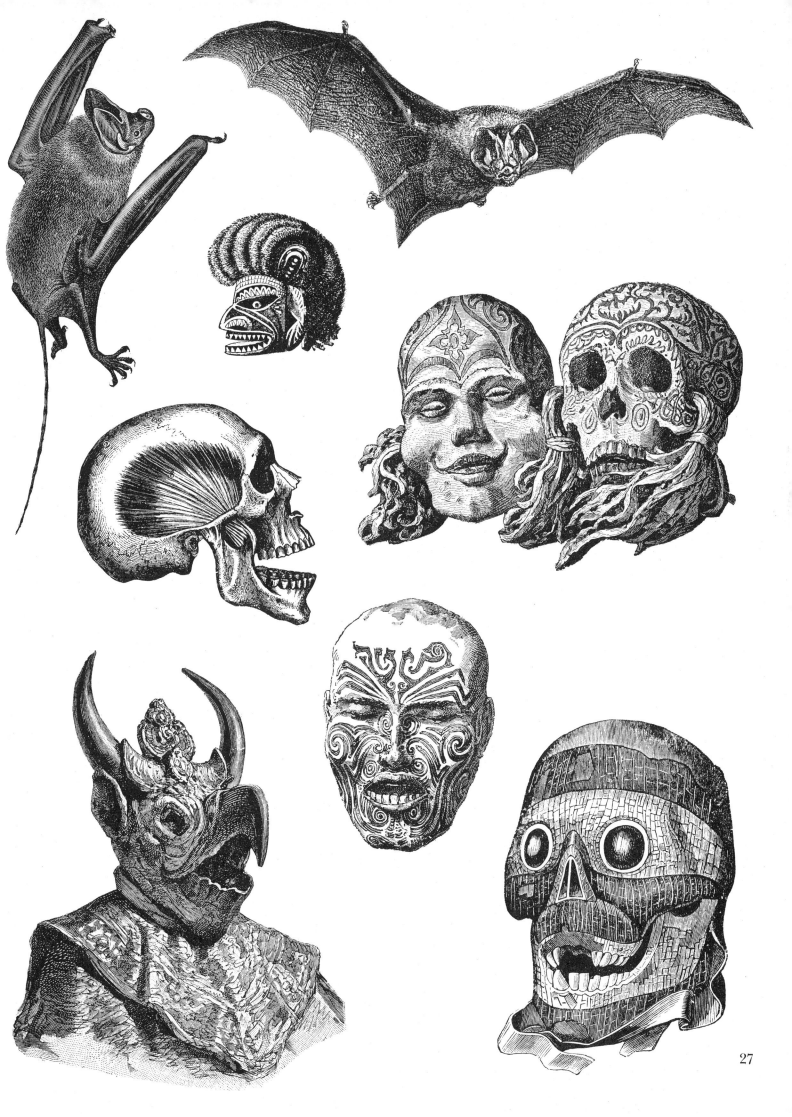

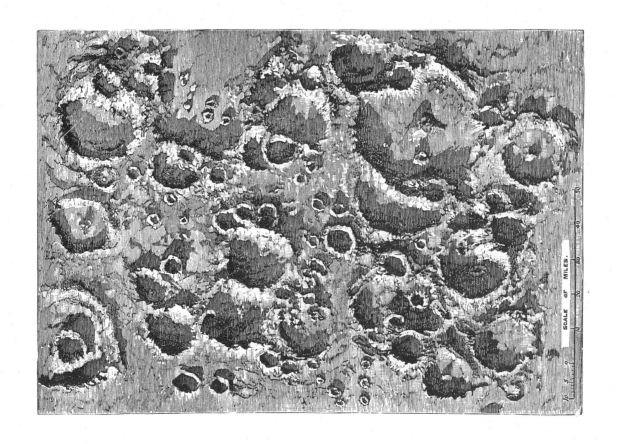

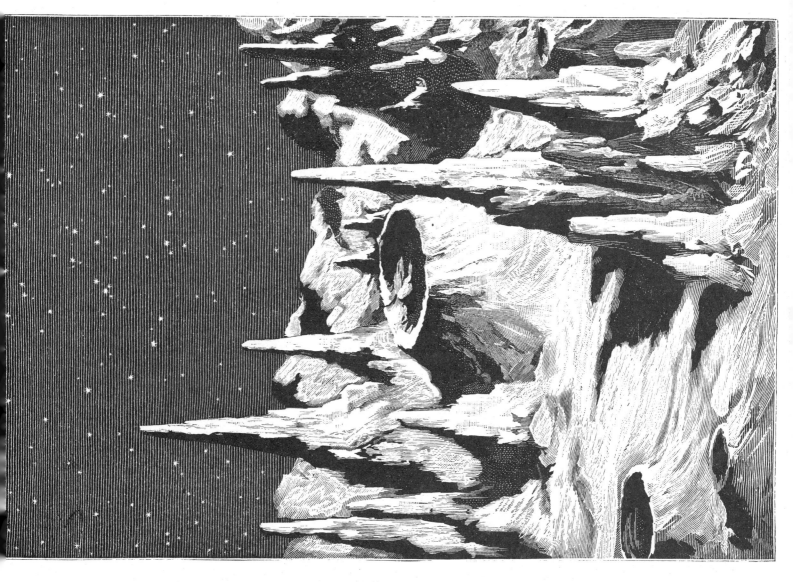

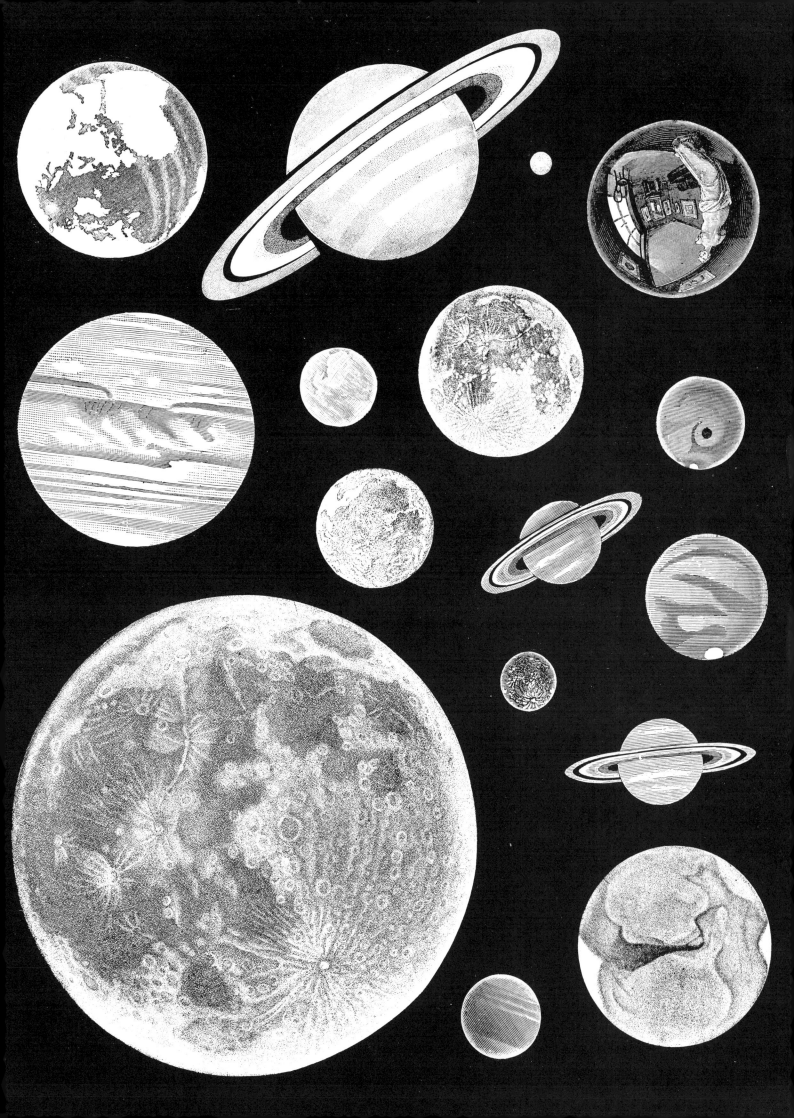

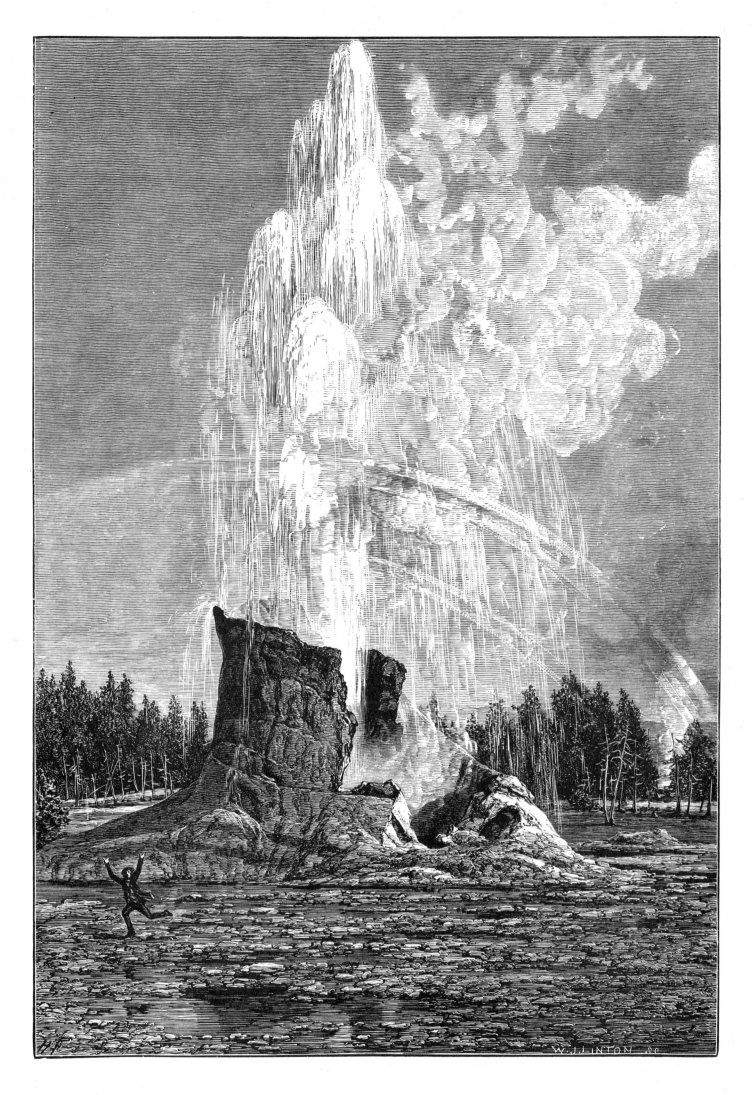

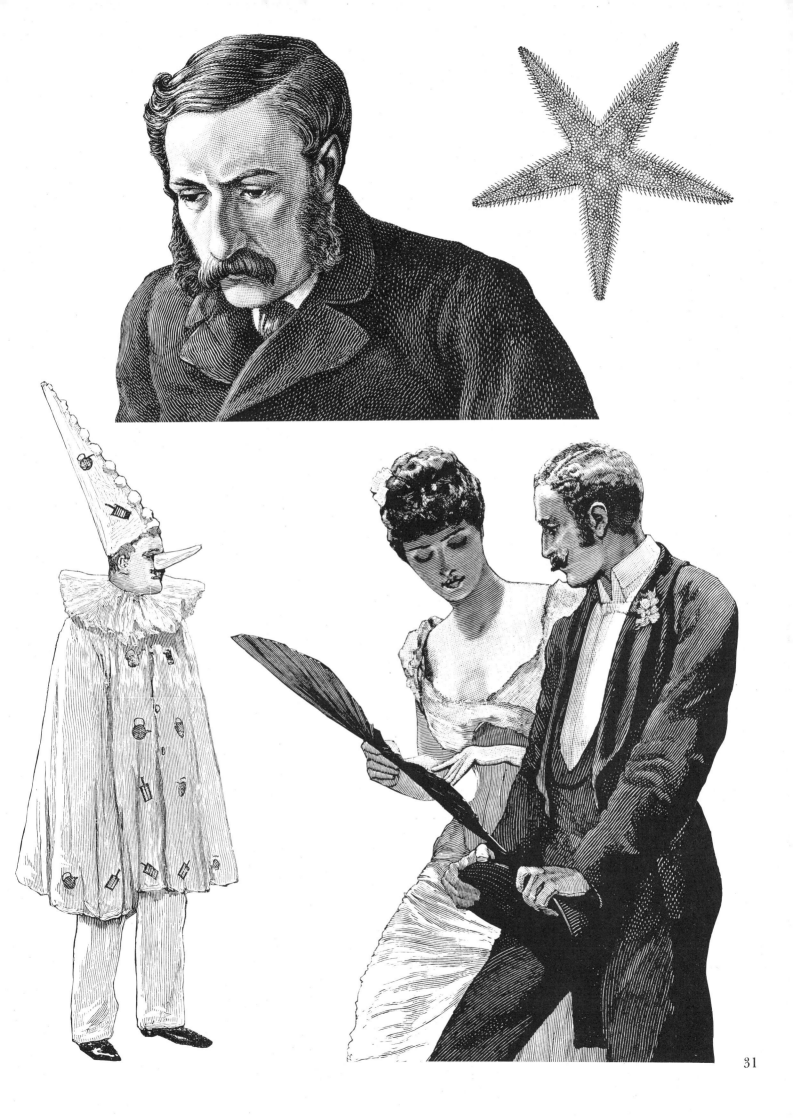

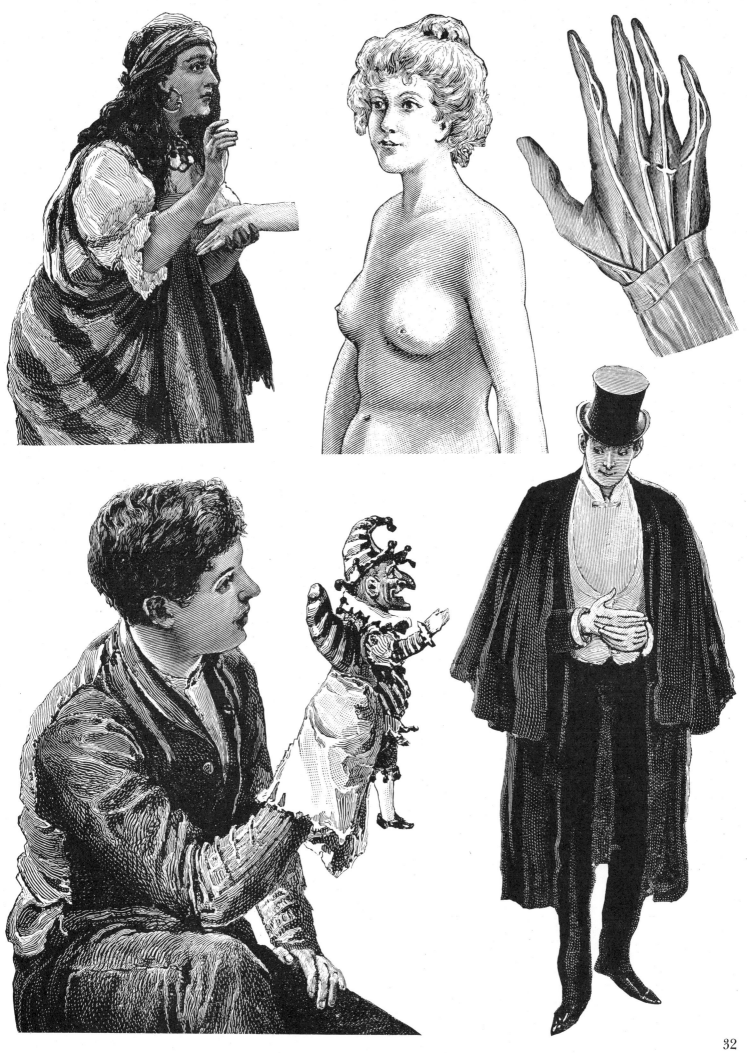

32

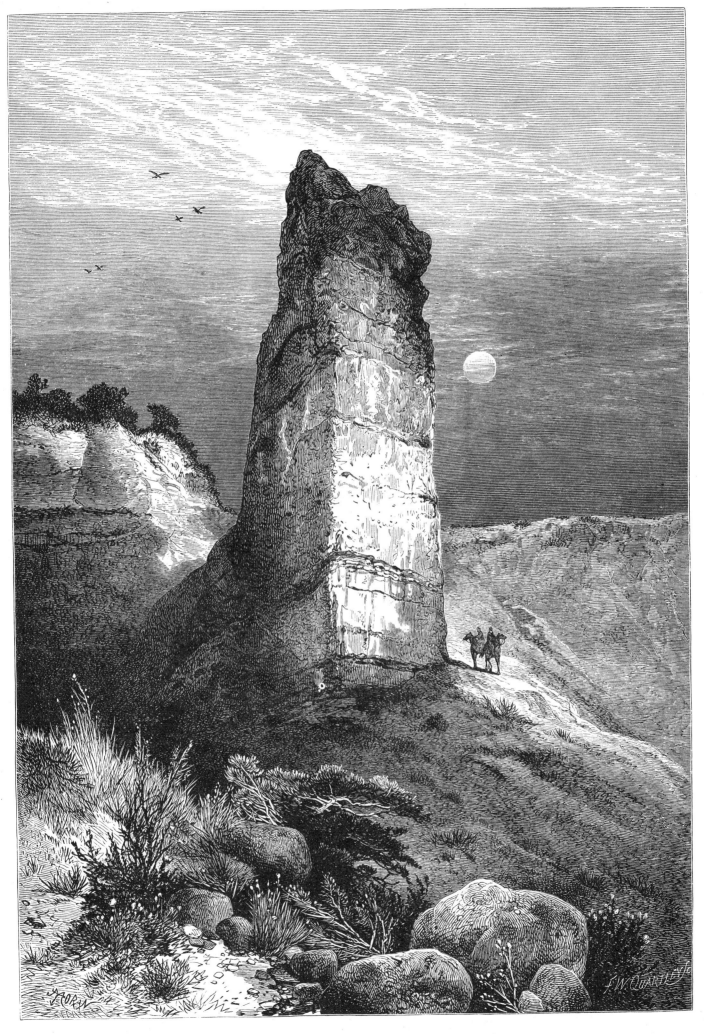

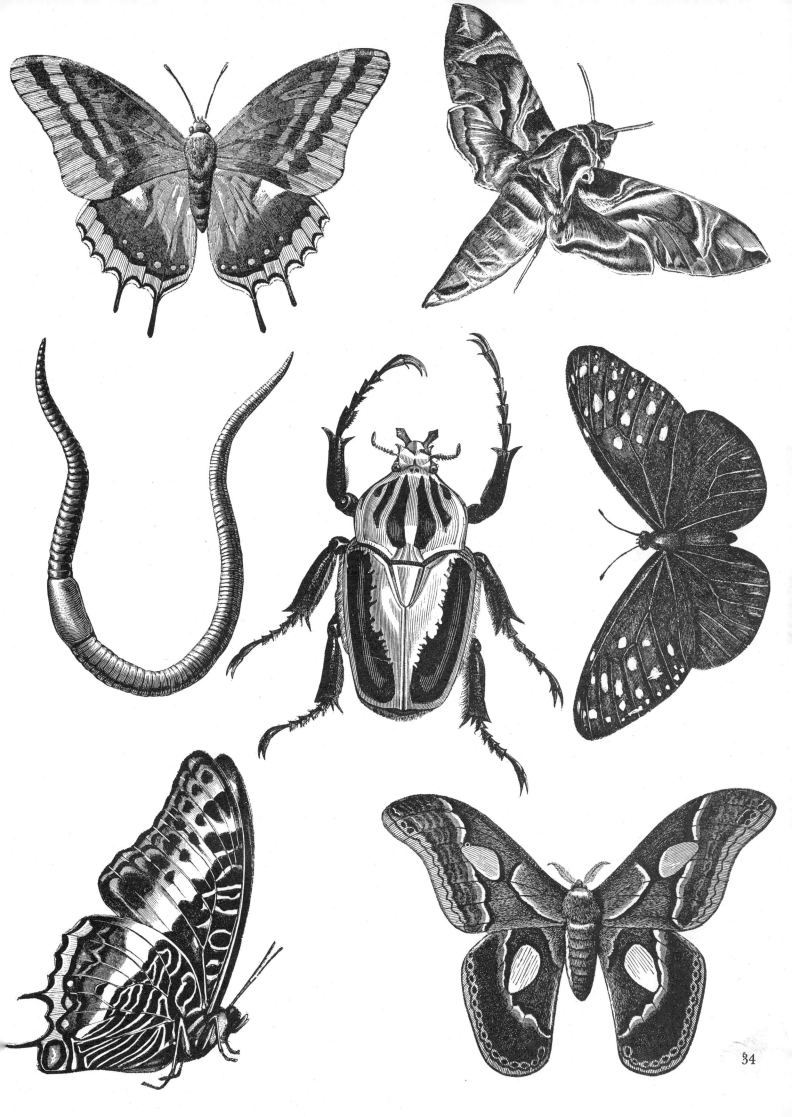

34

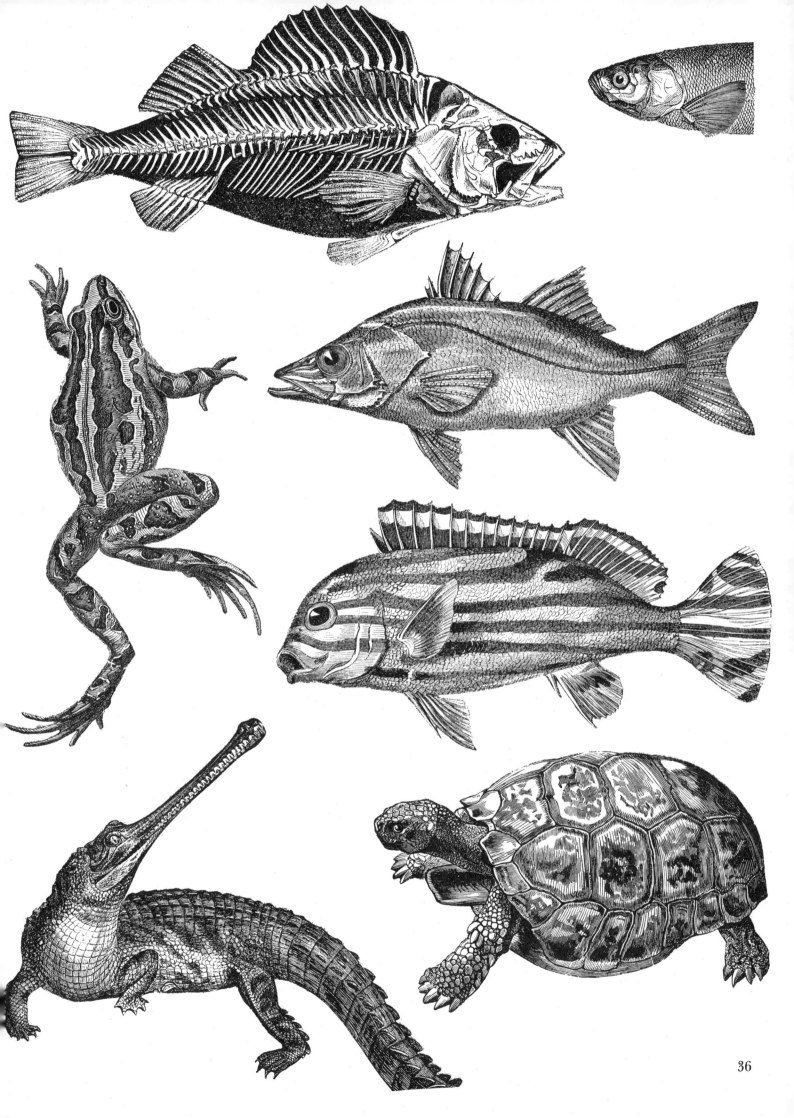

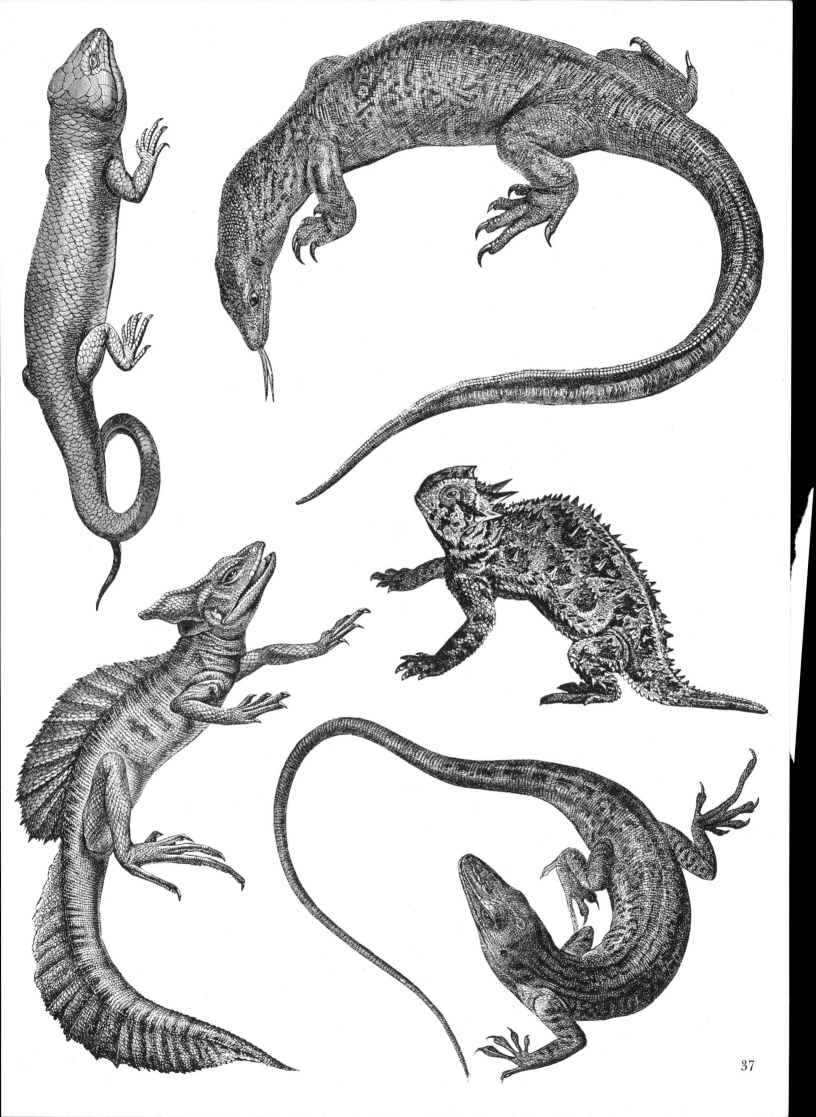

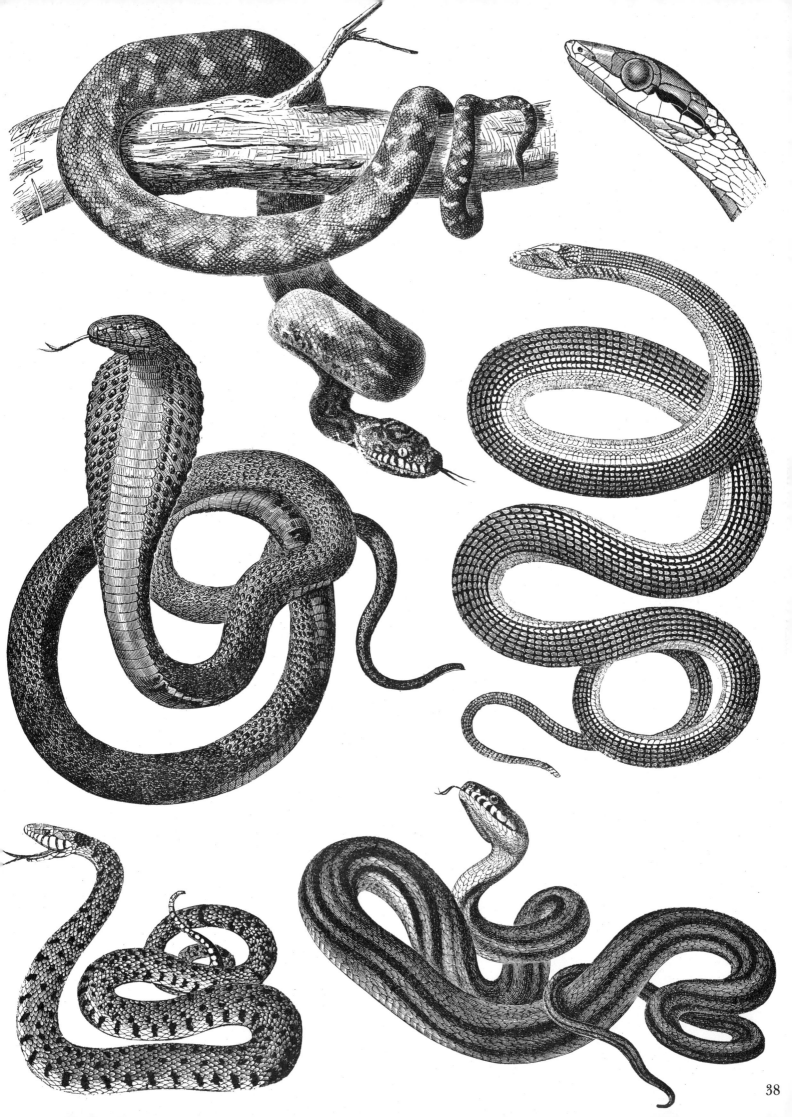

38

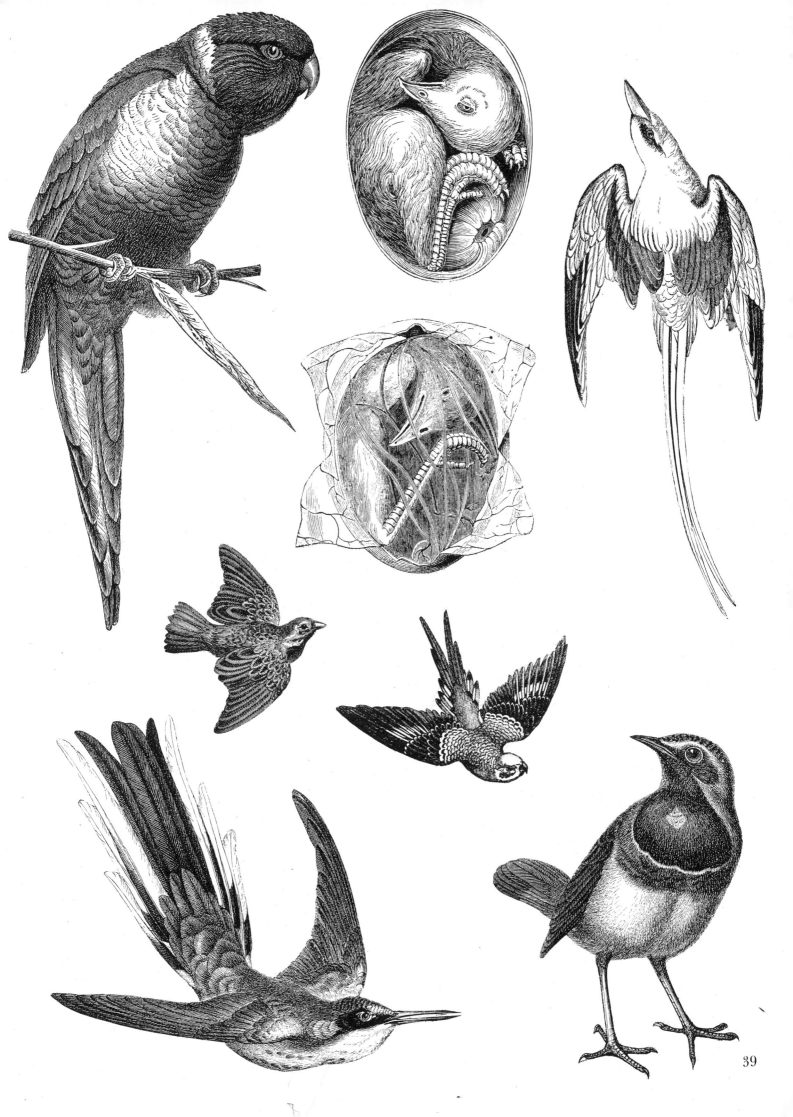

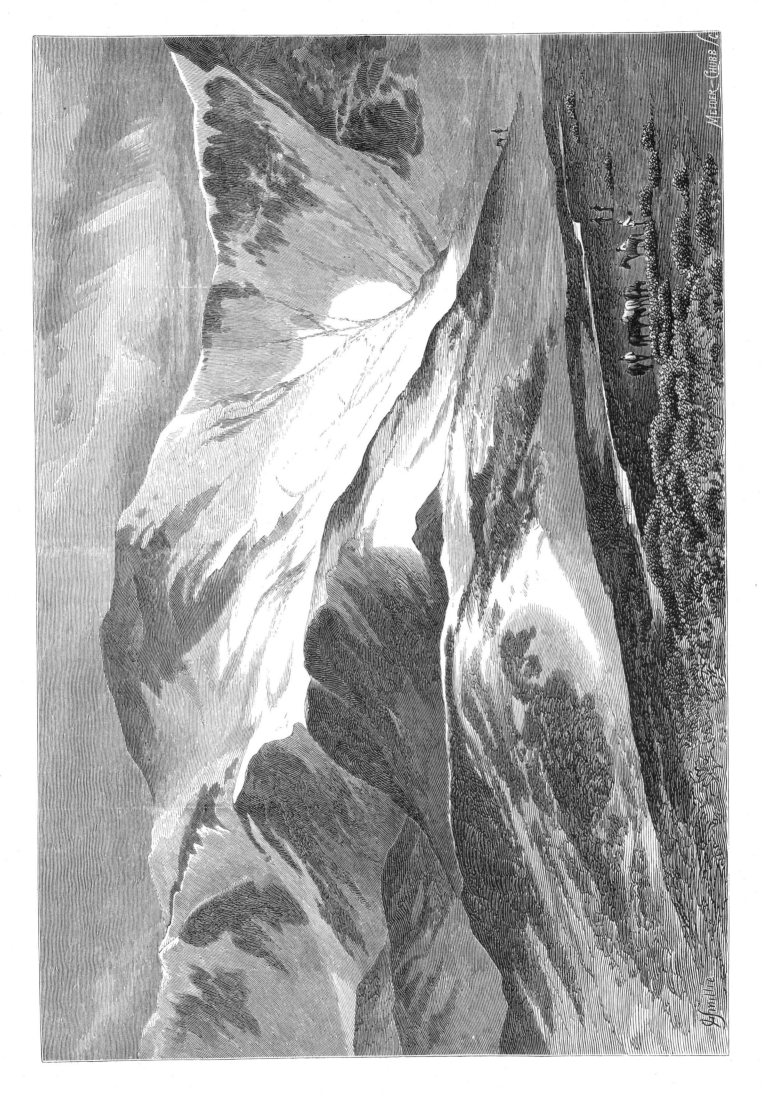

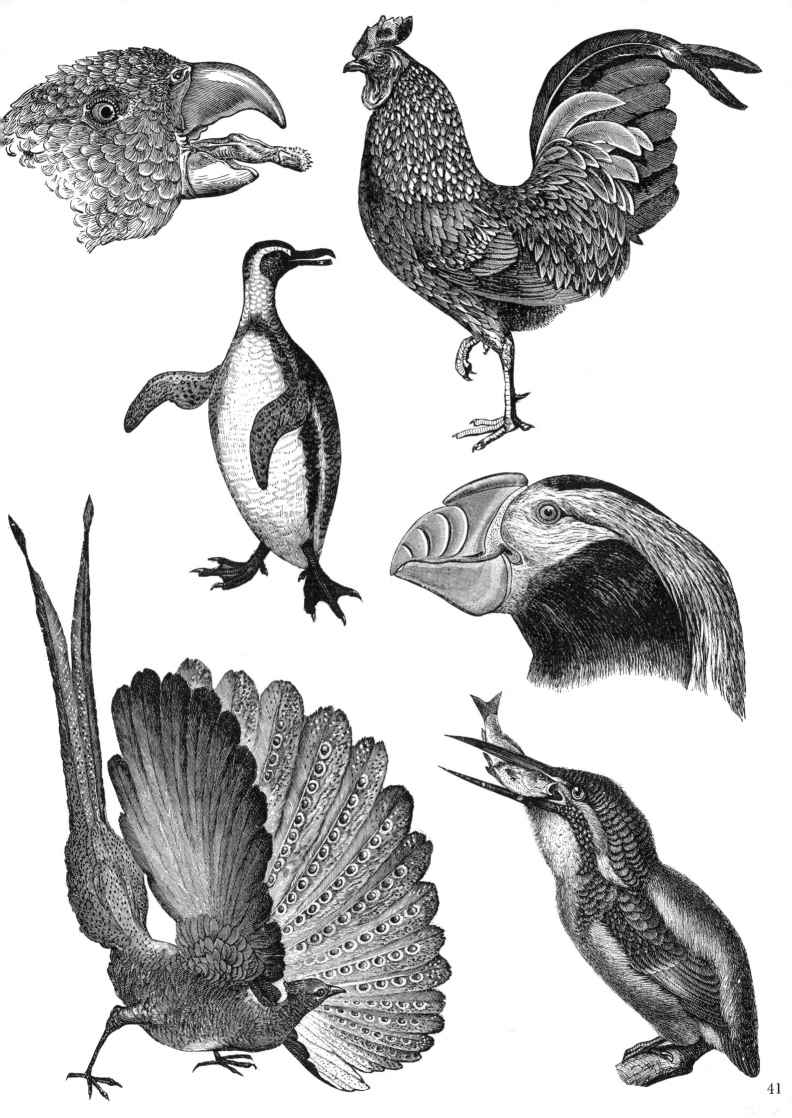

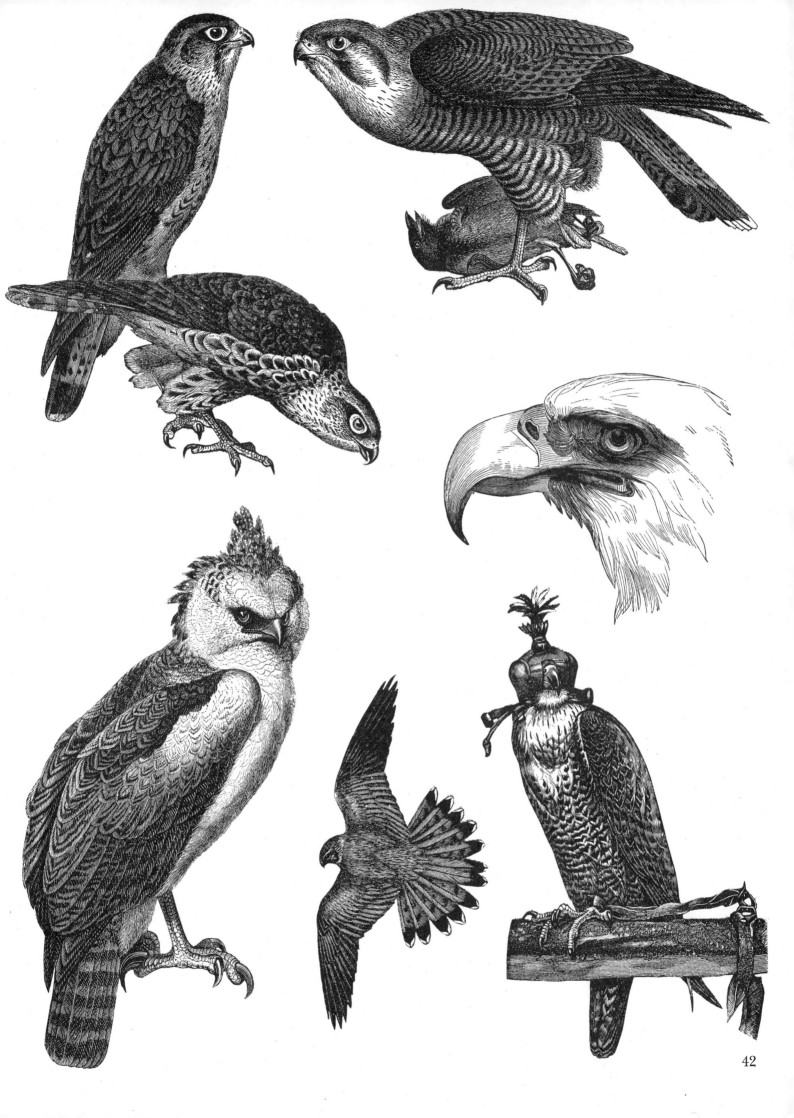

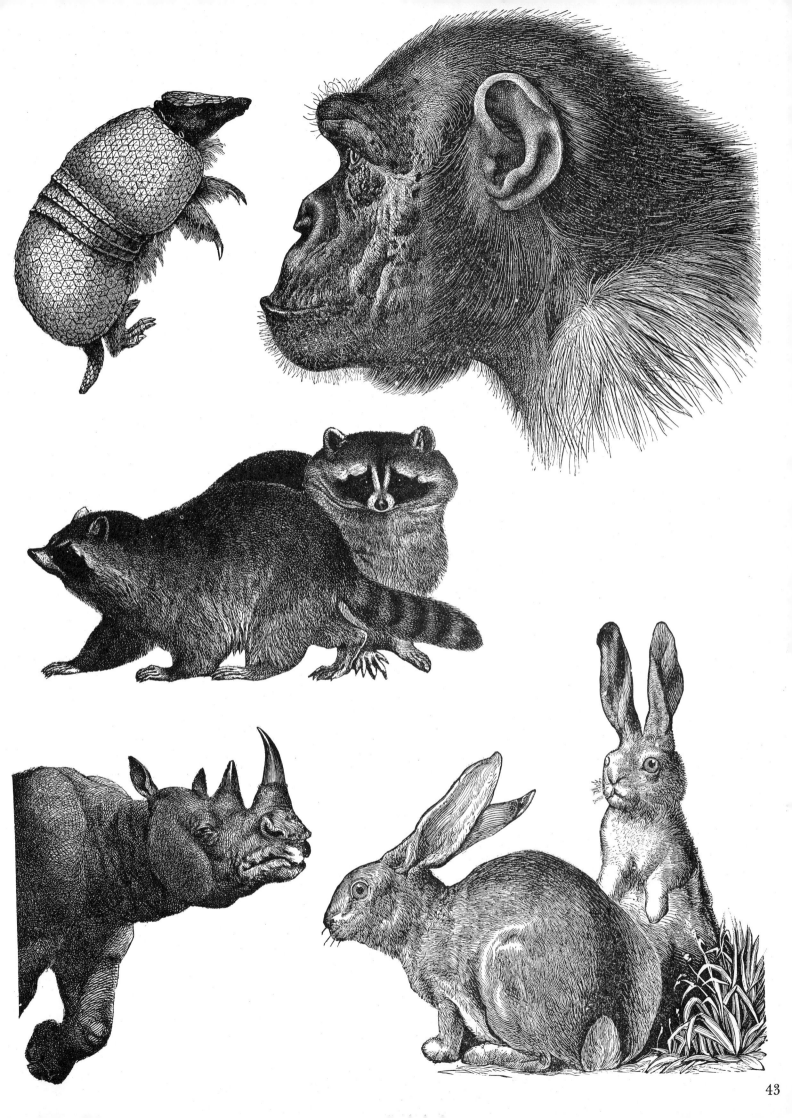

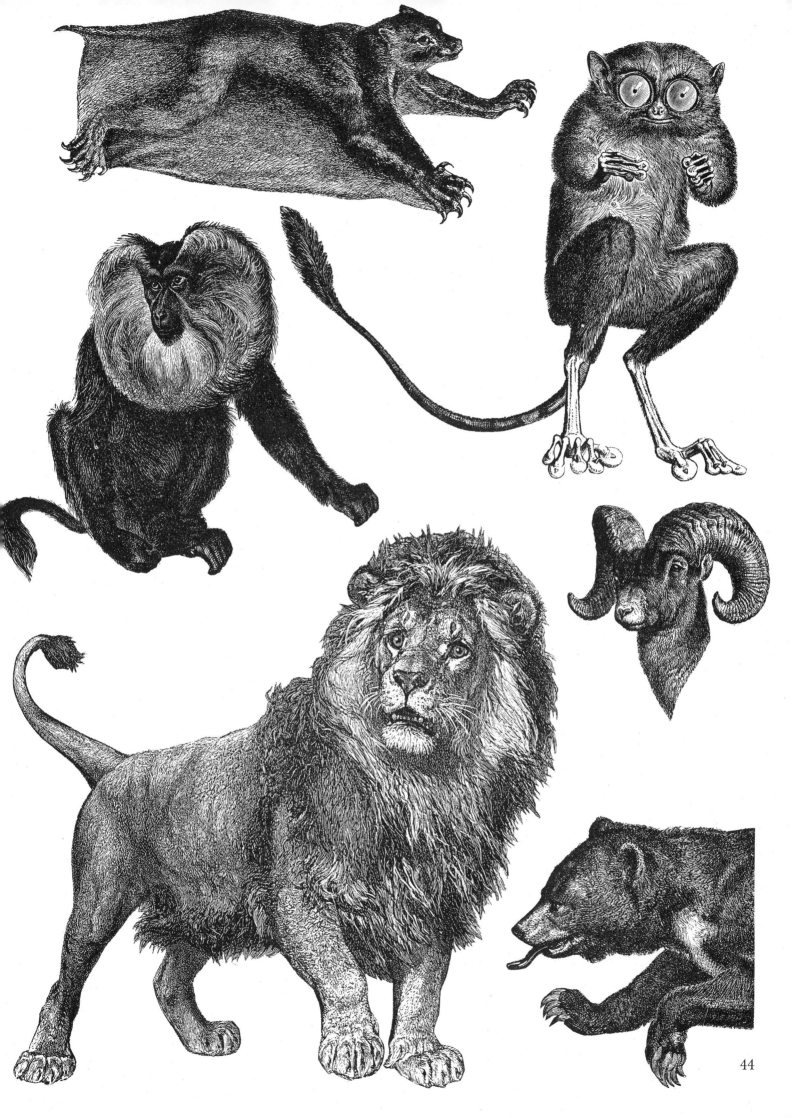

44

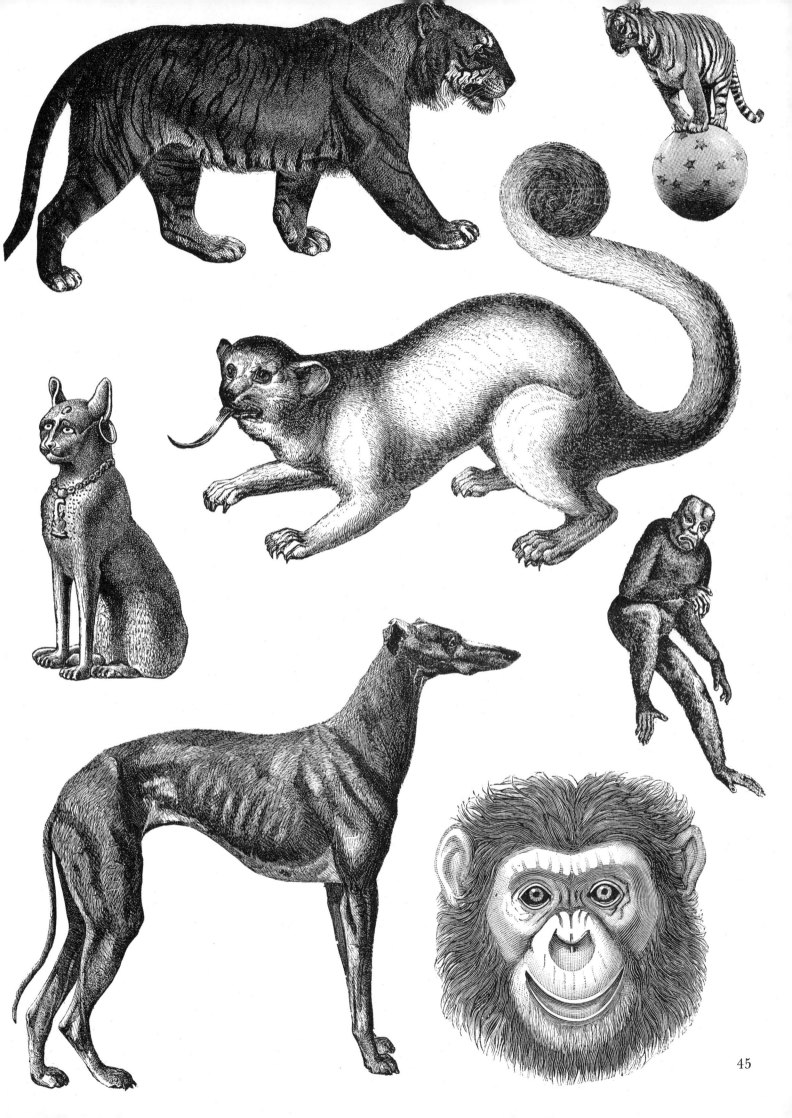

45

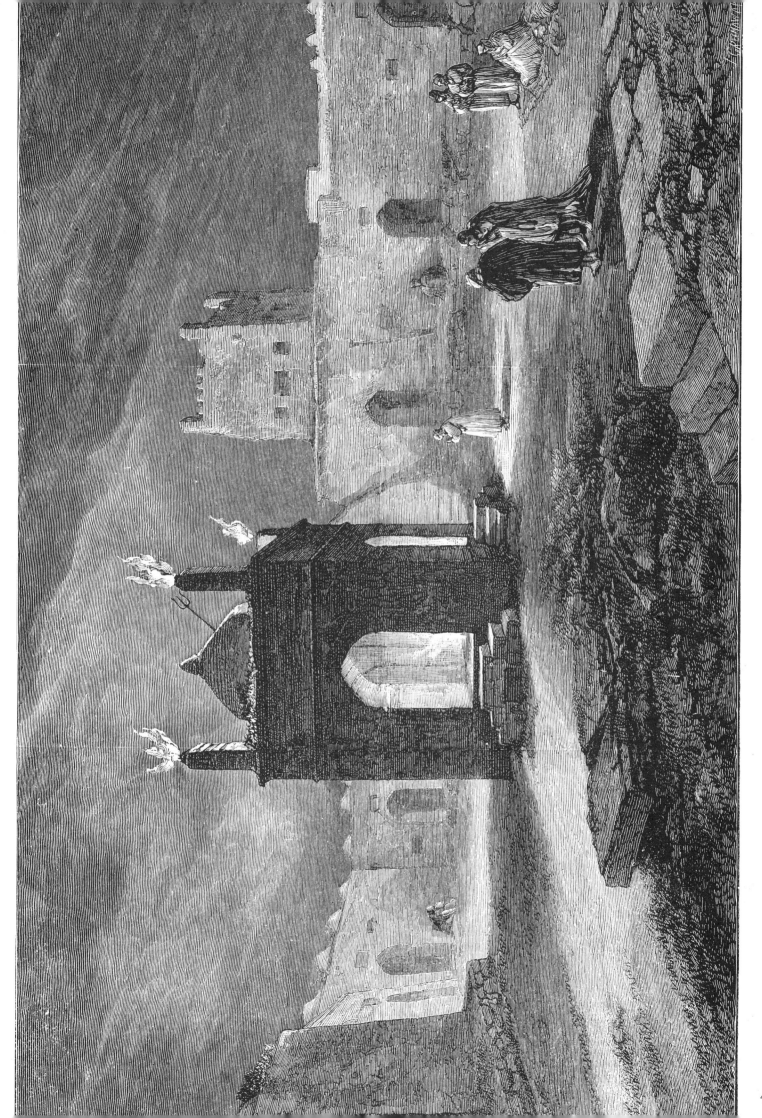

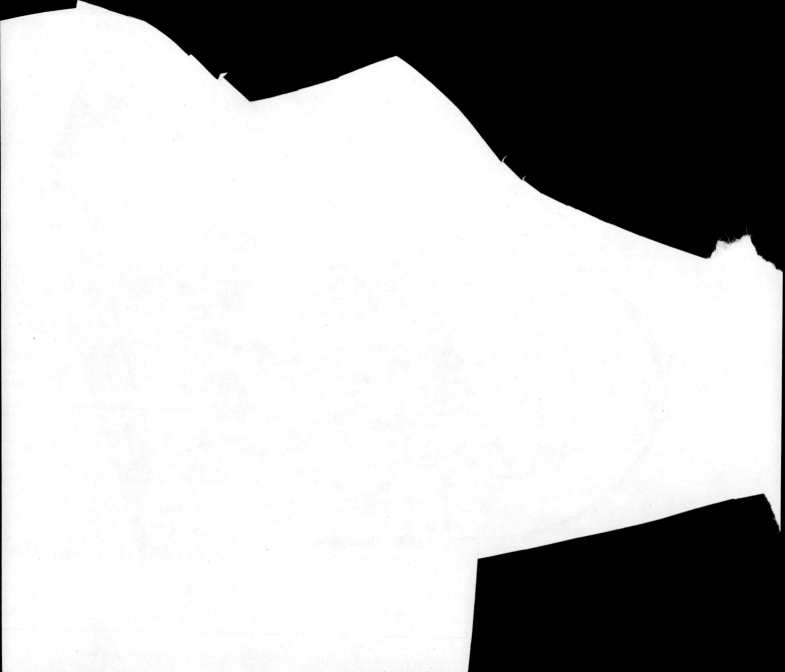

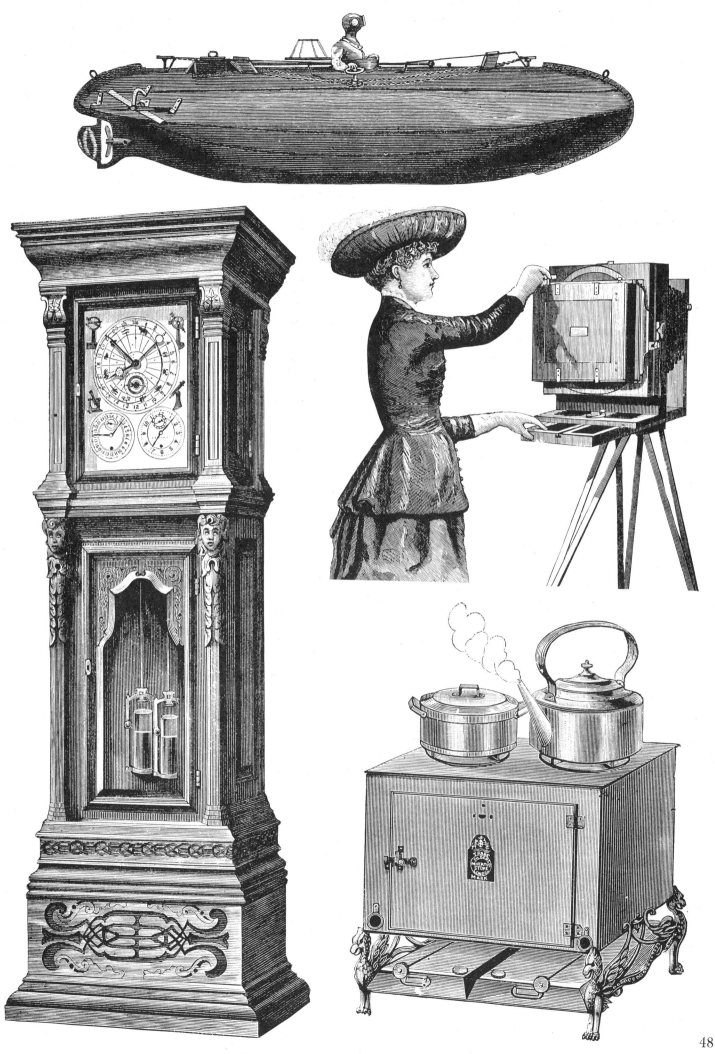

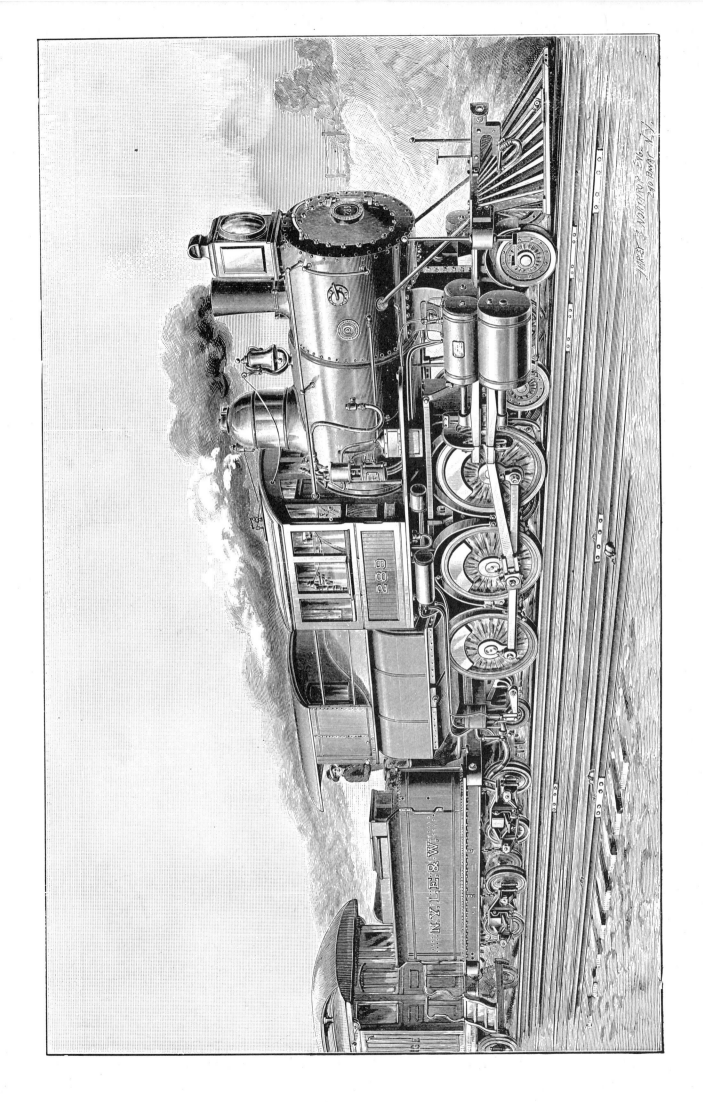

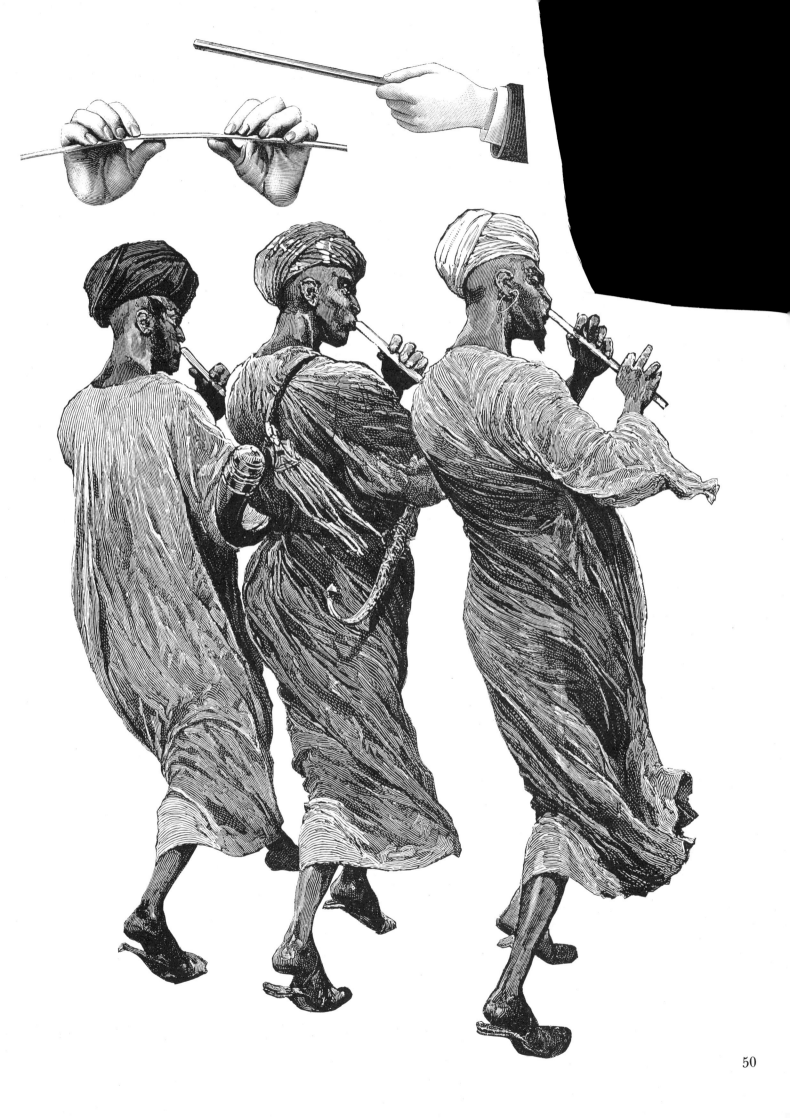

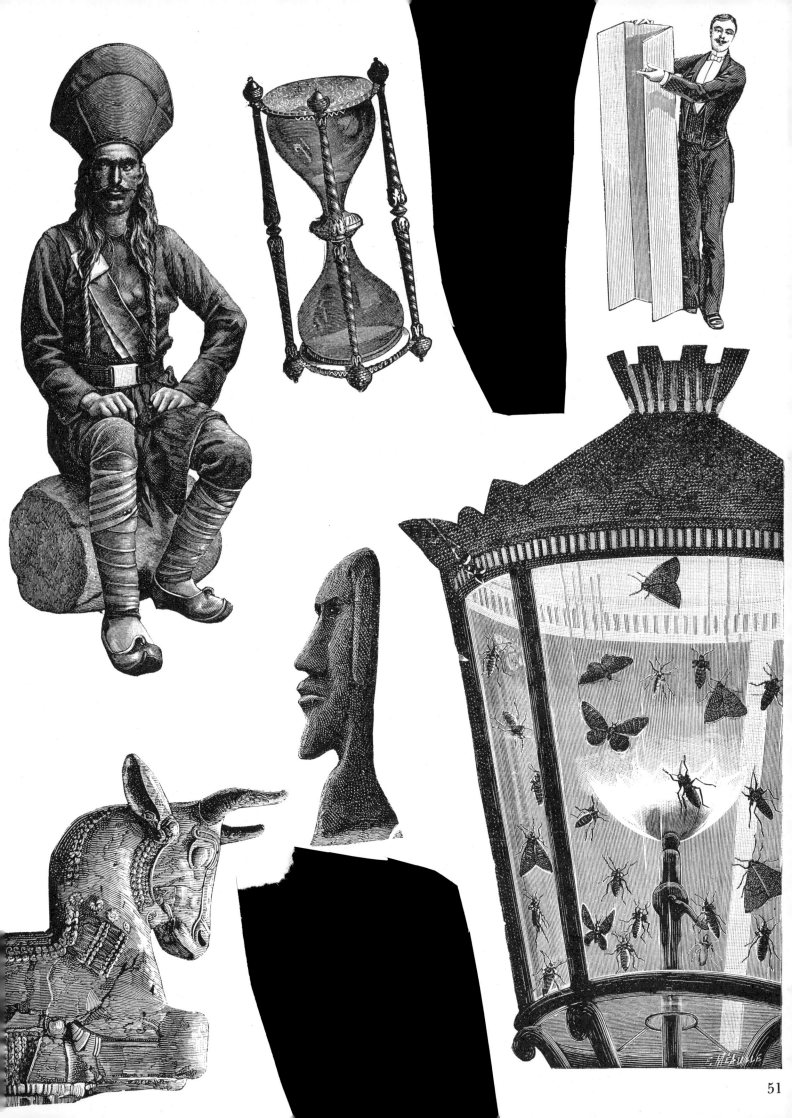

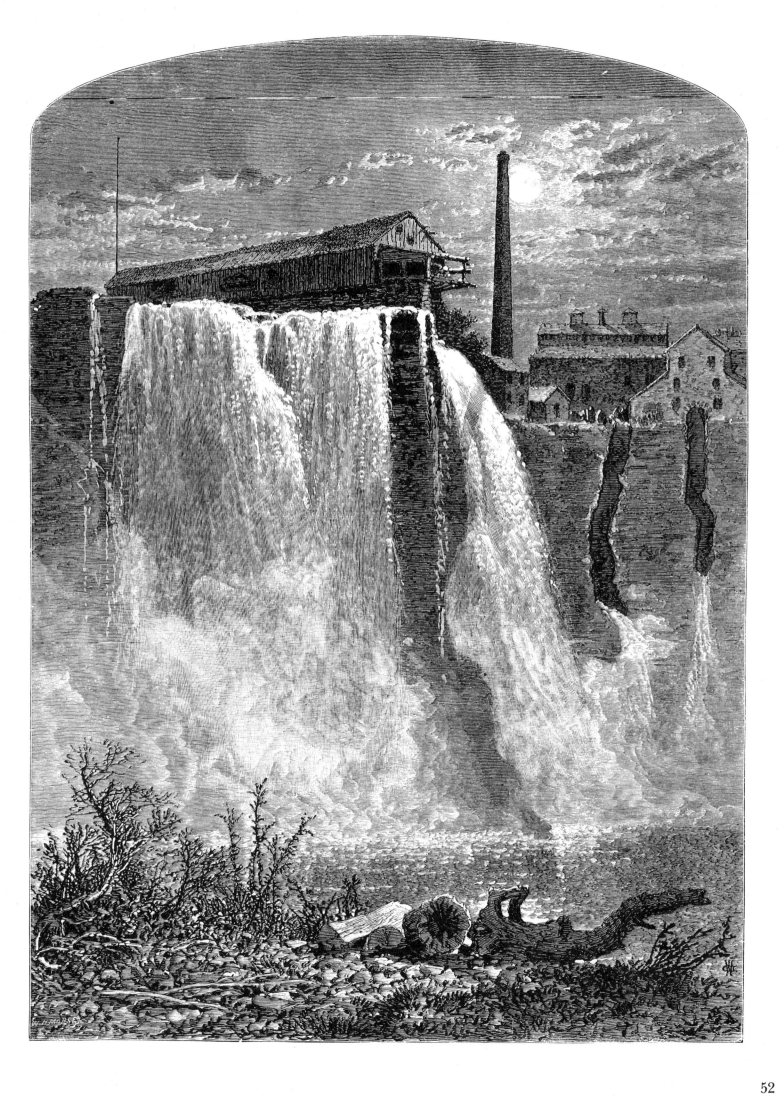

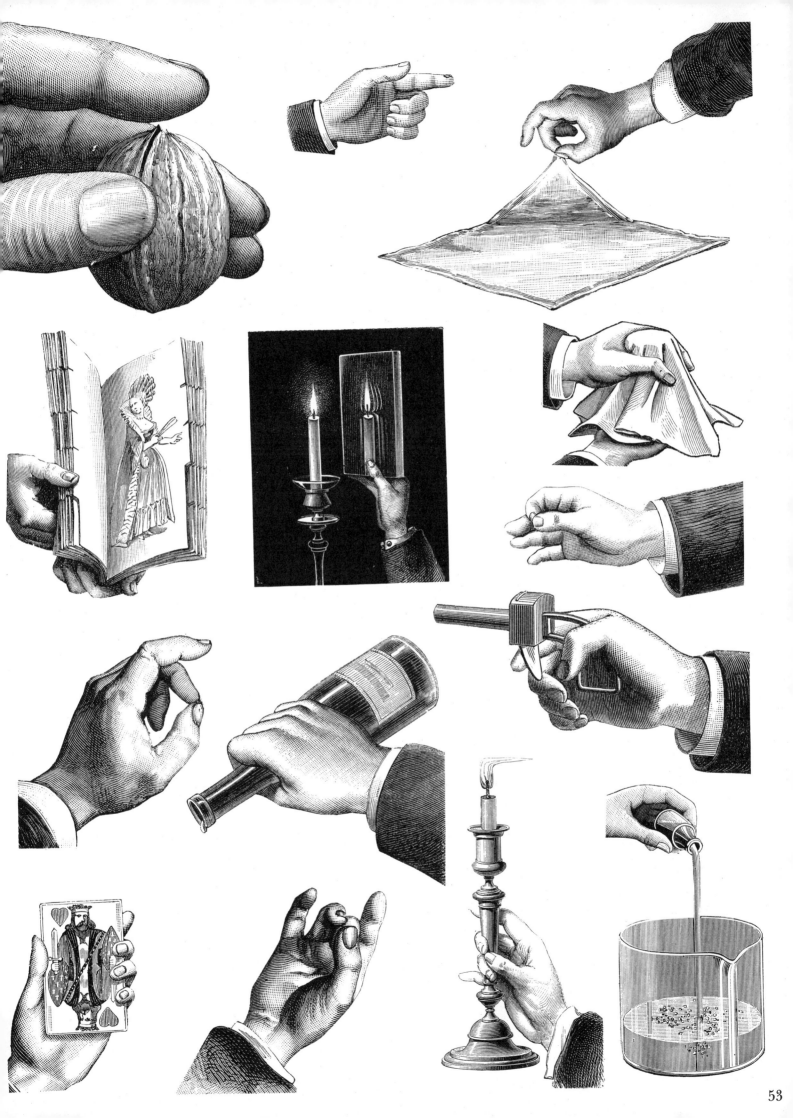

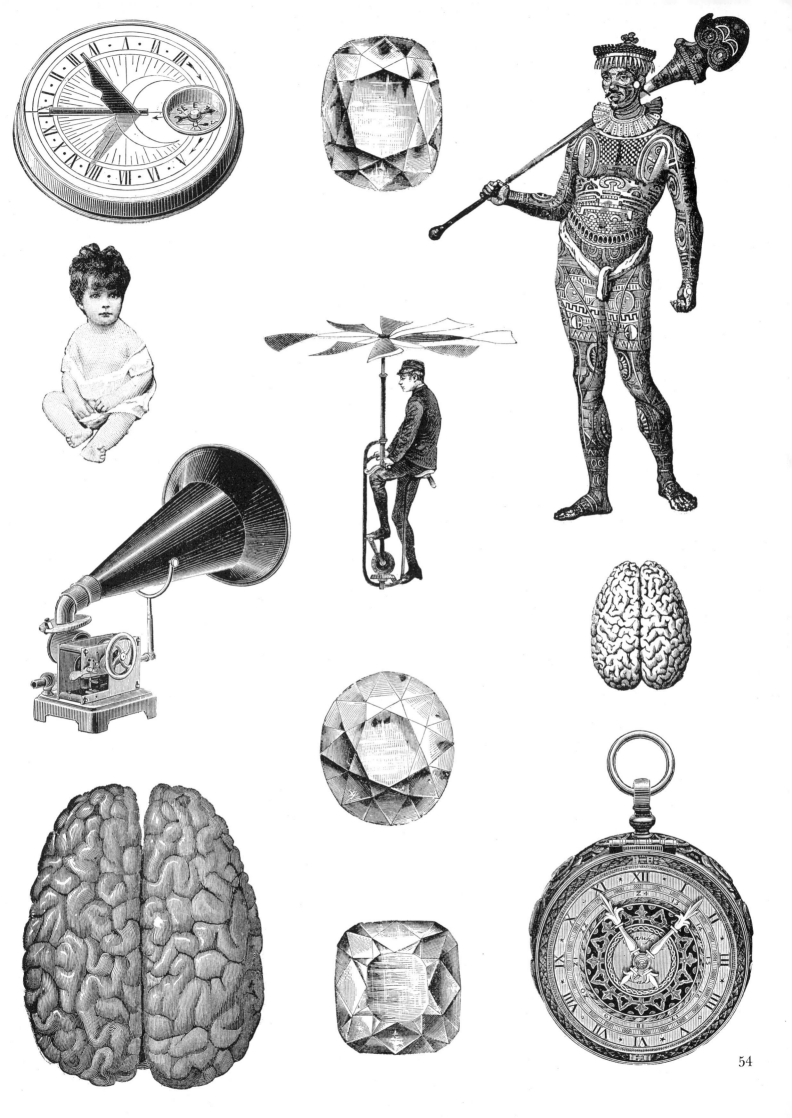

54

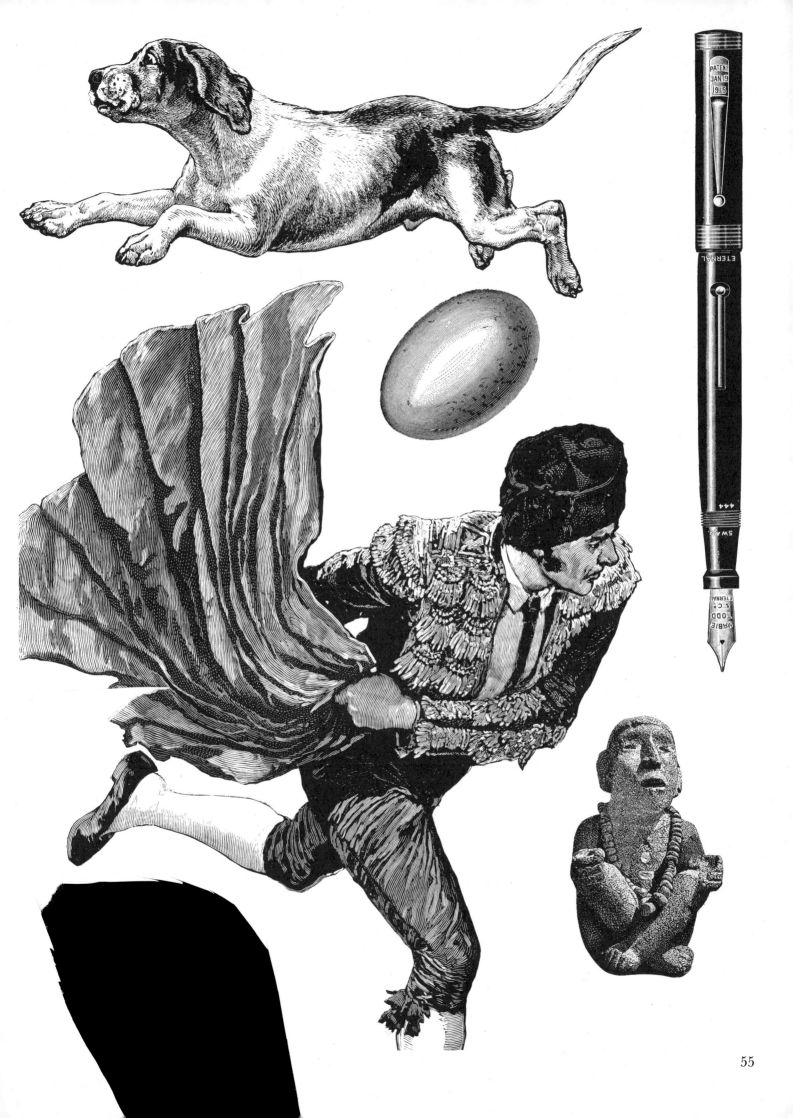

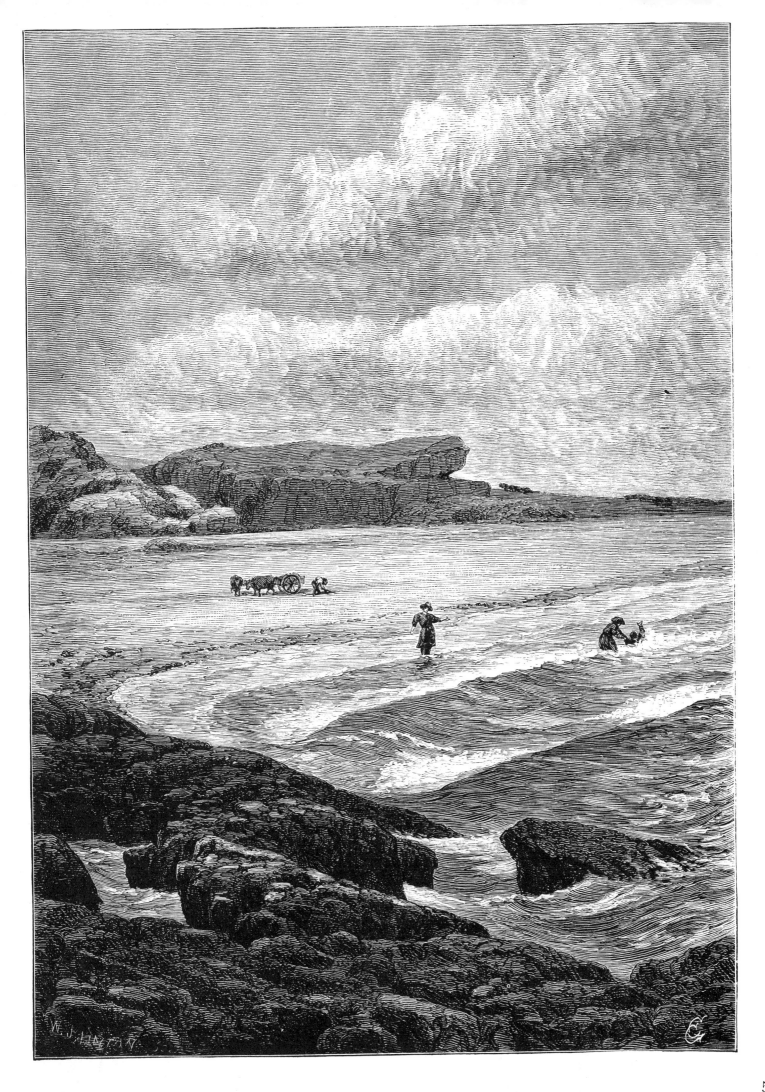

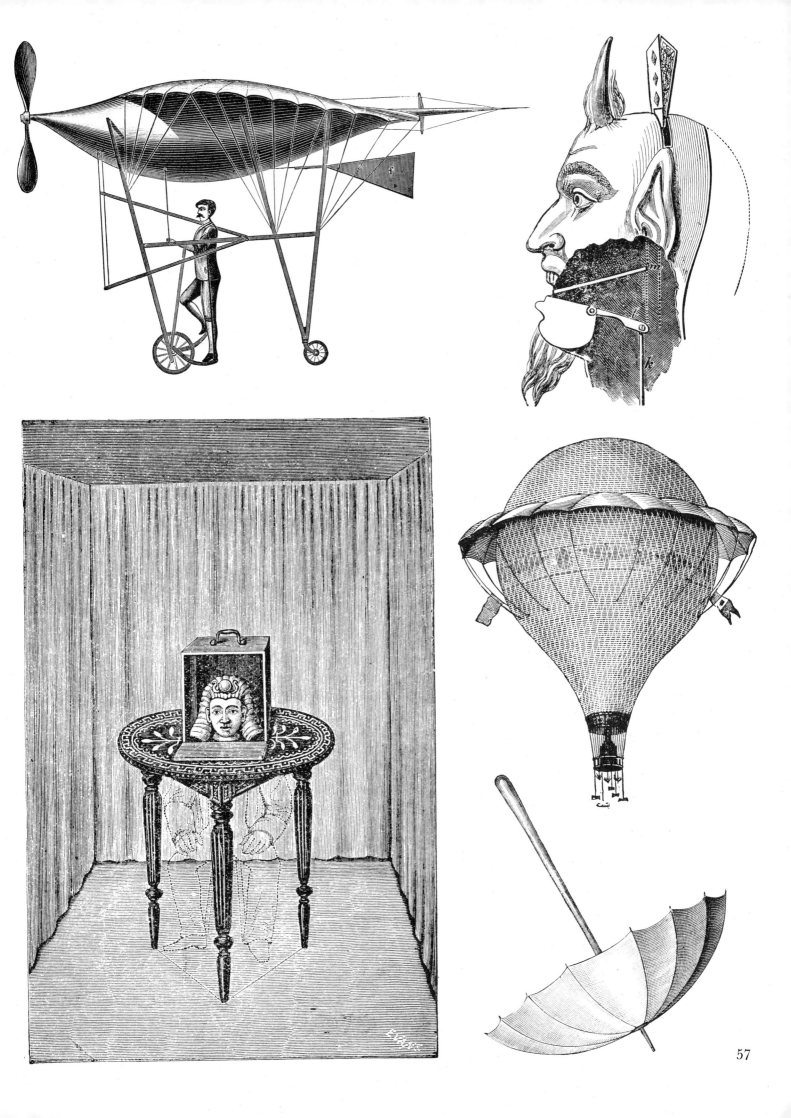

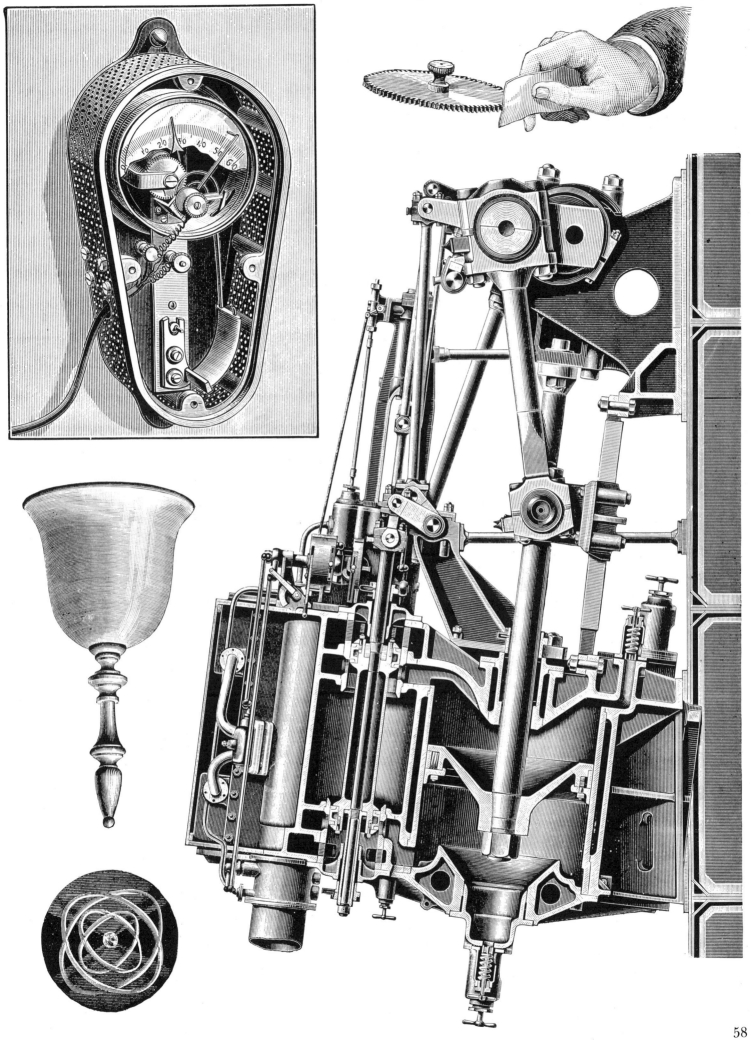

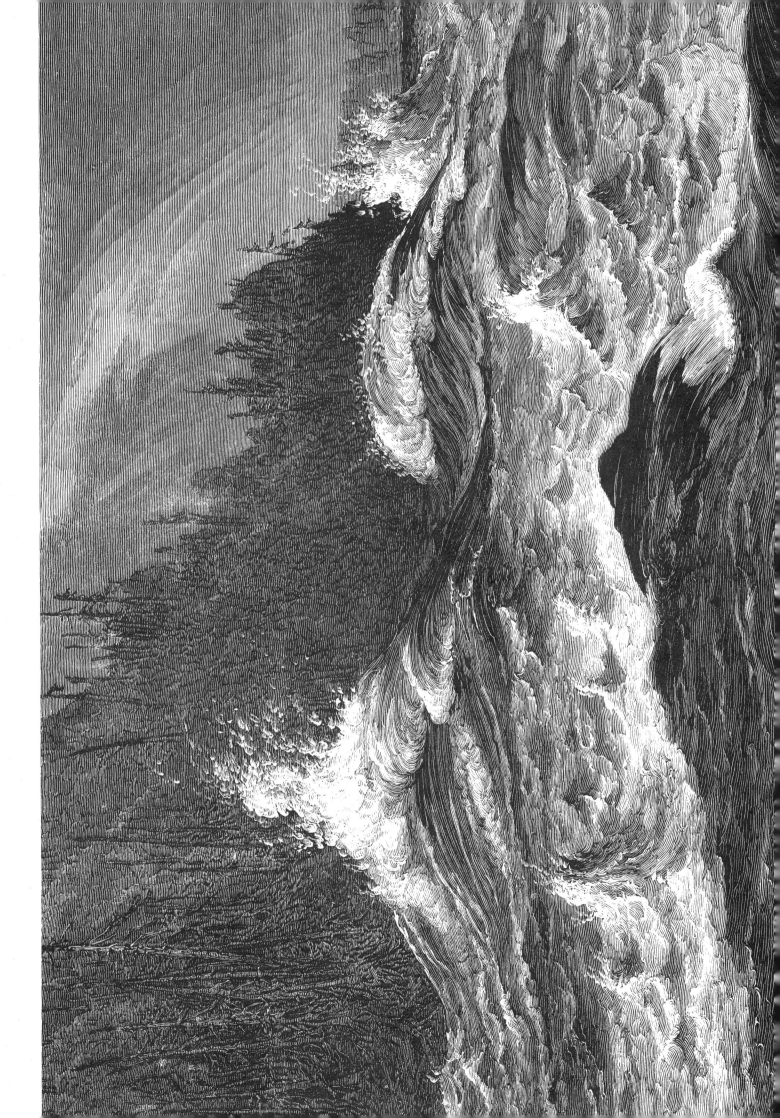

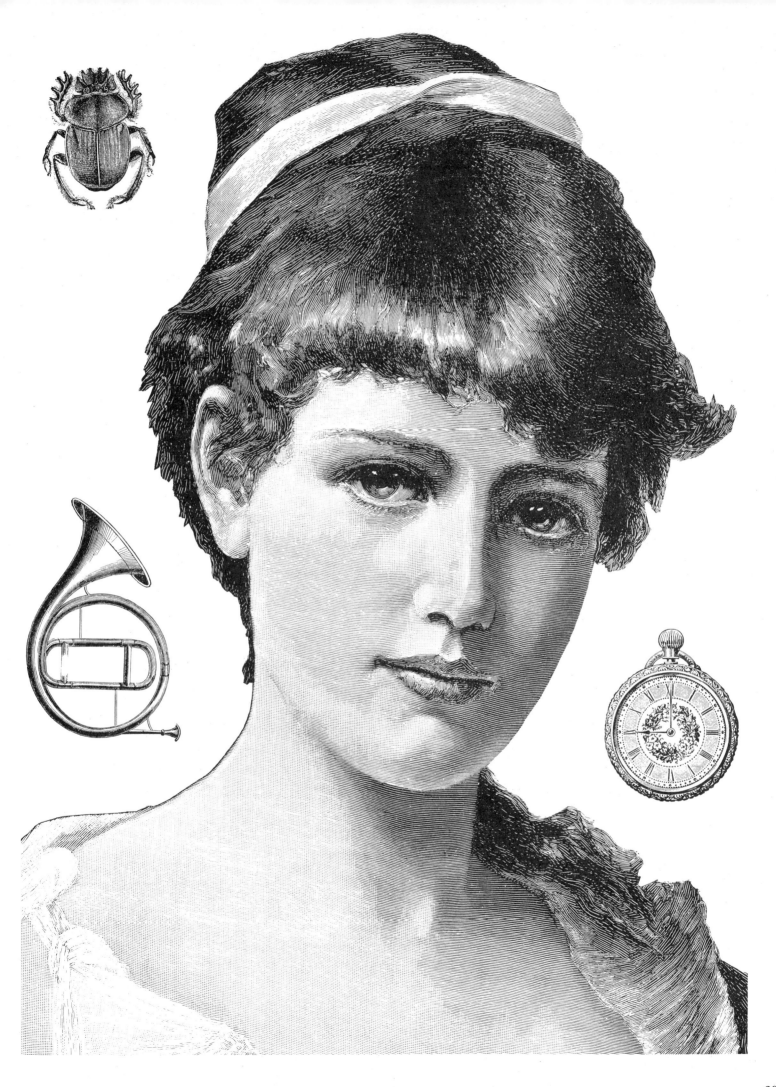

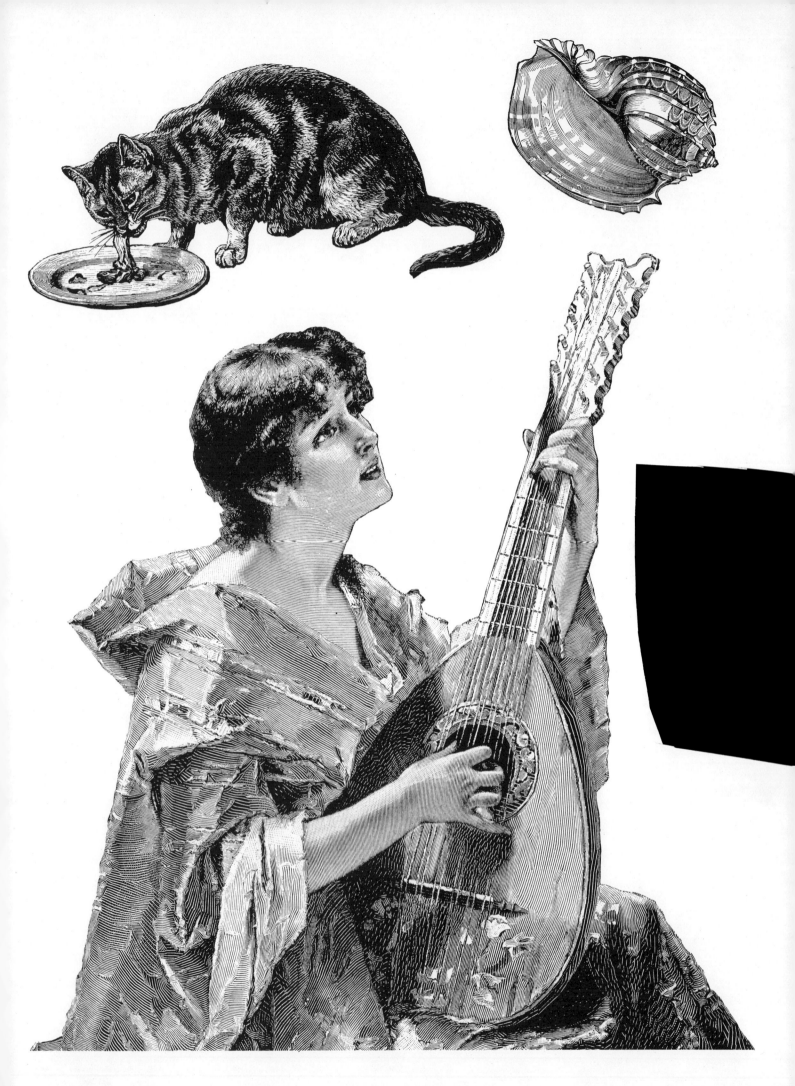

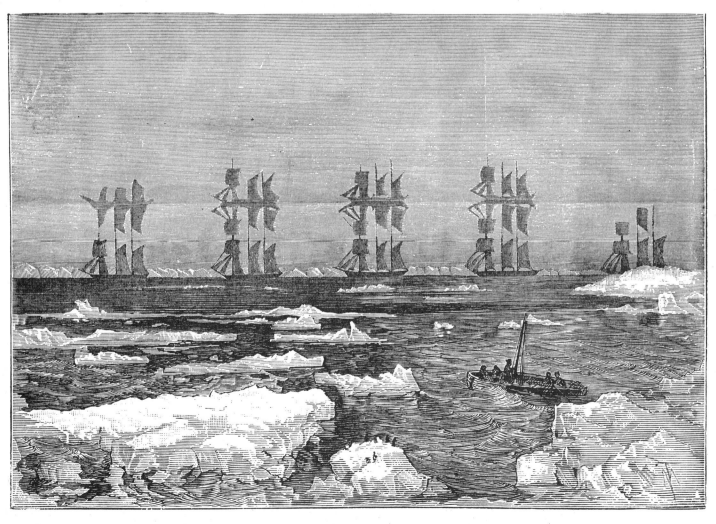

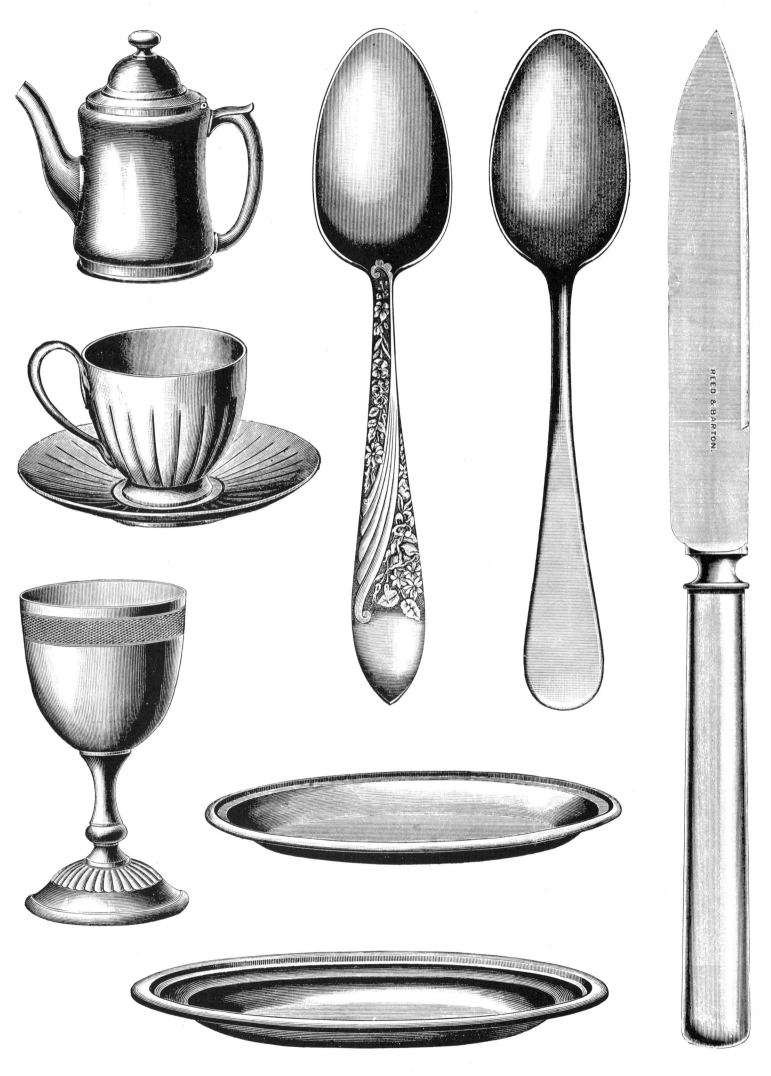

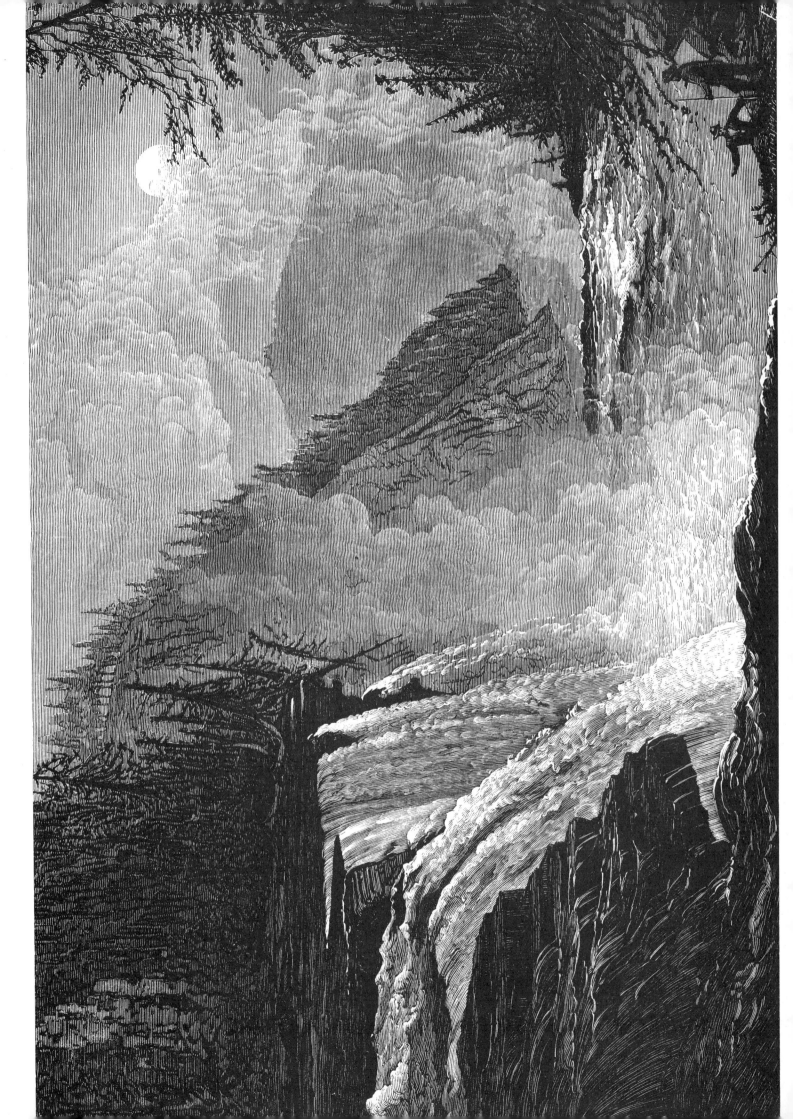

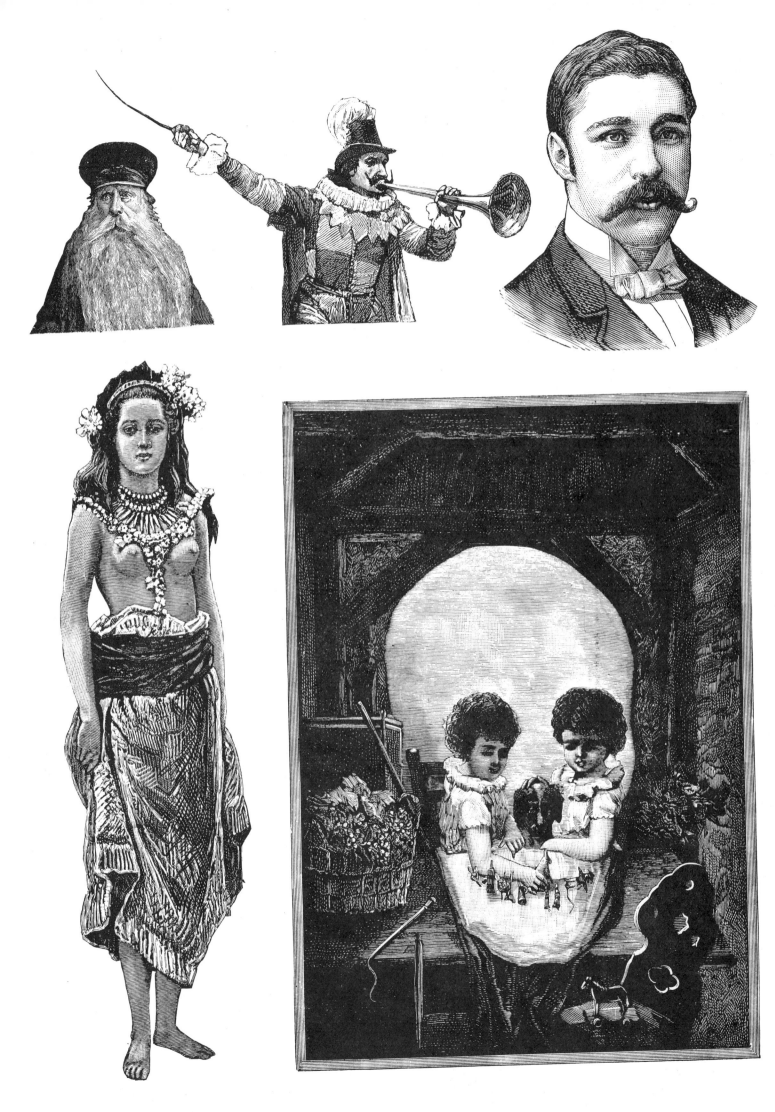

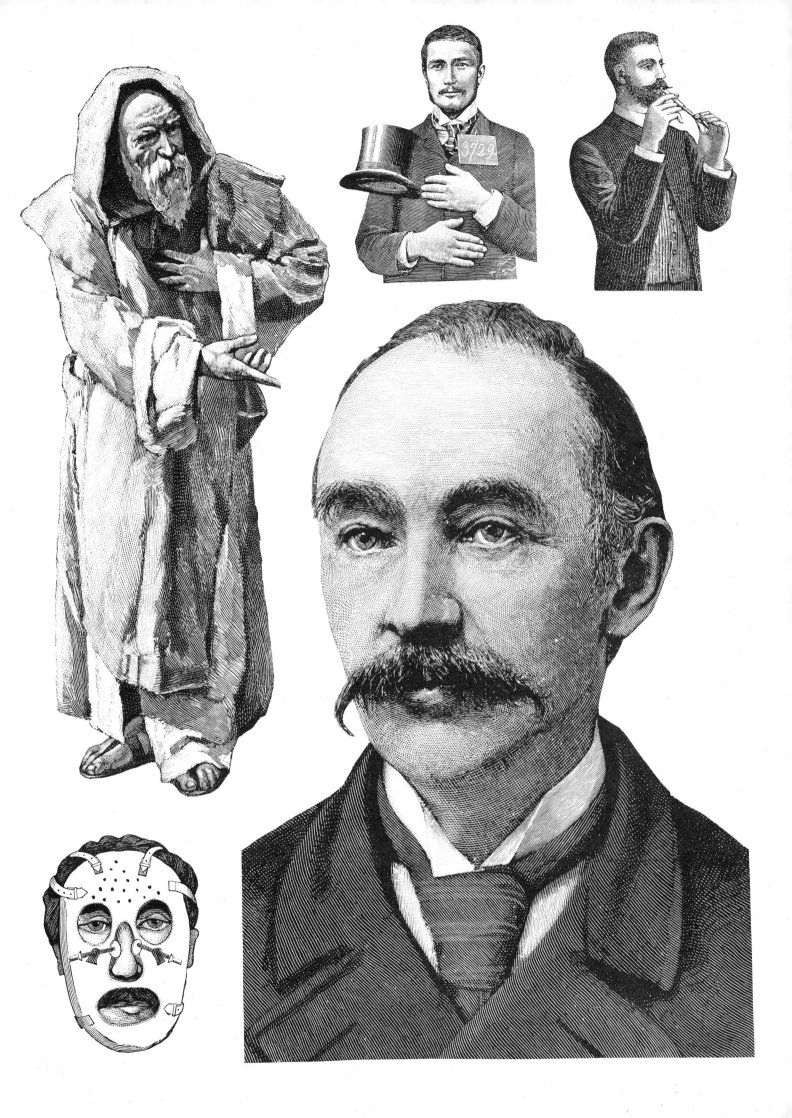

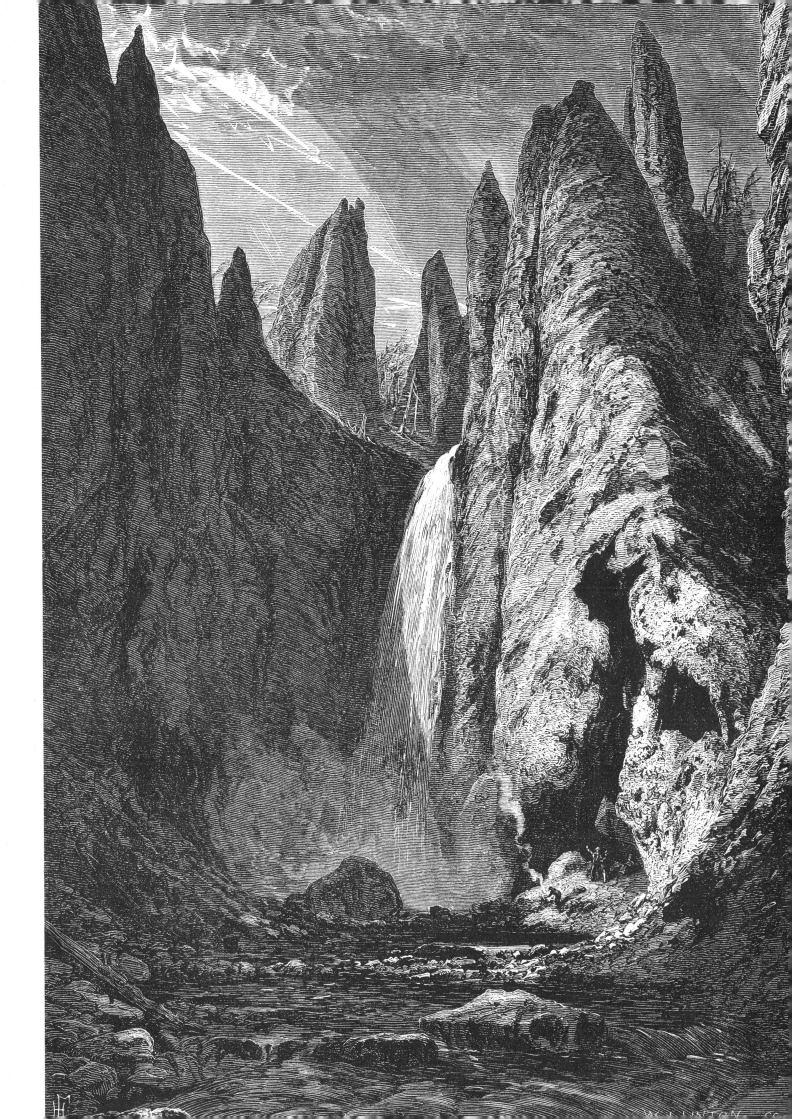

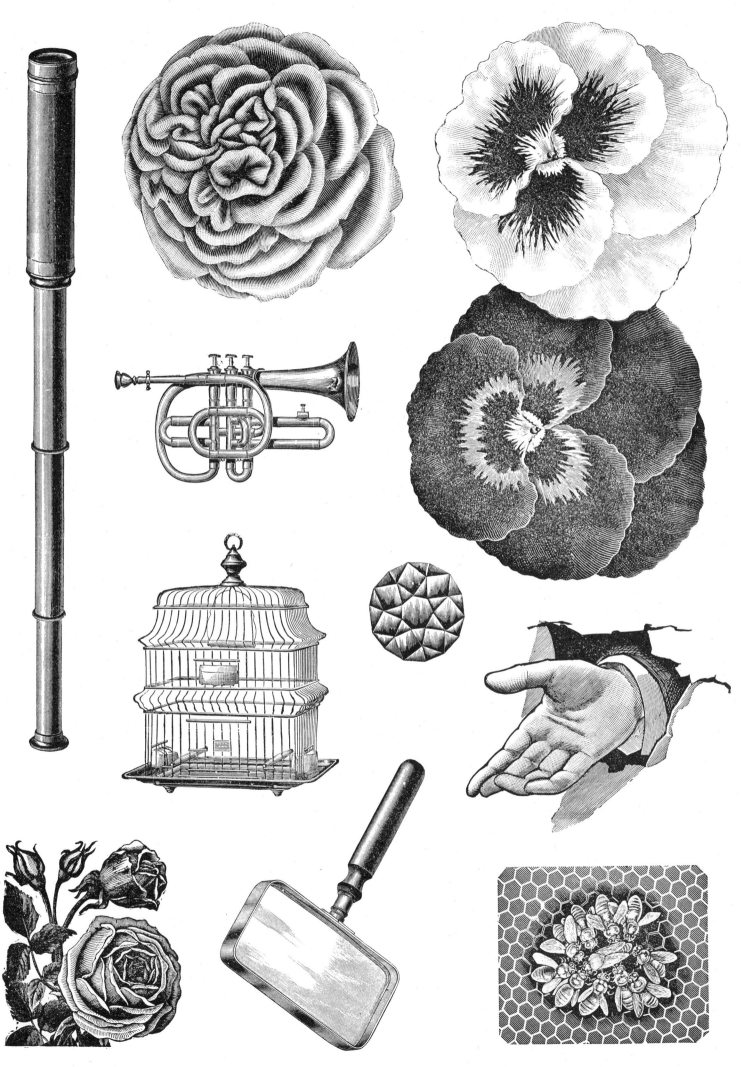

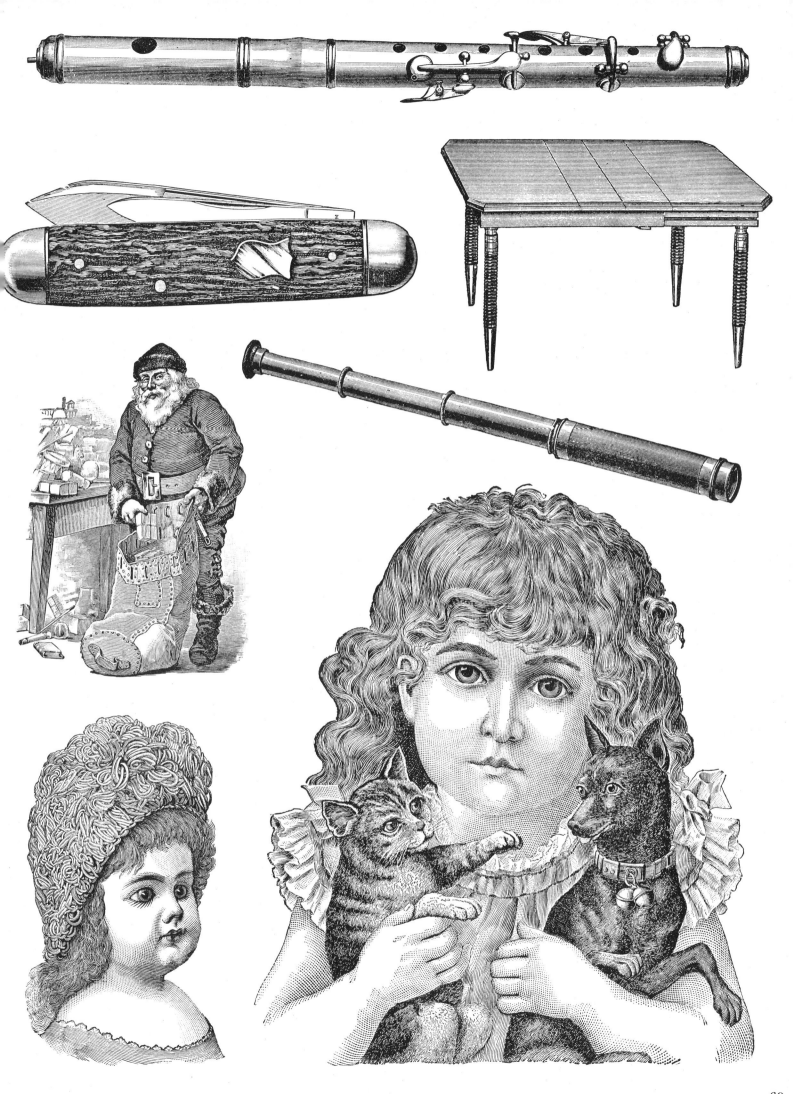

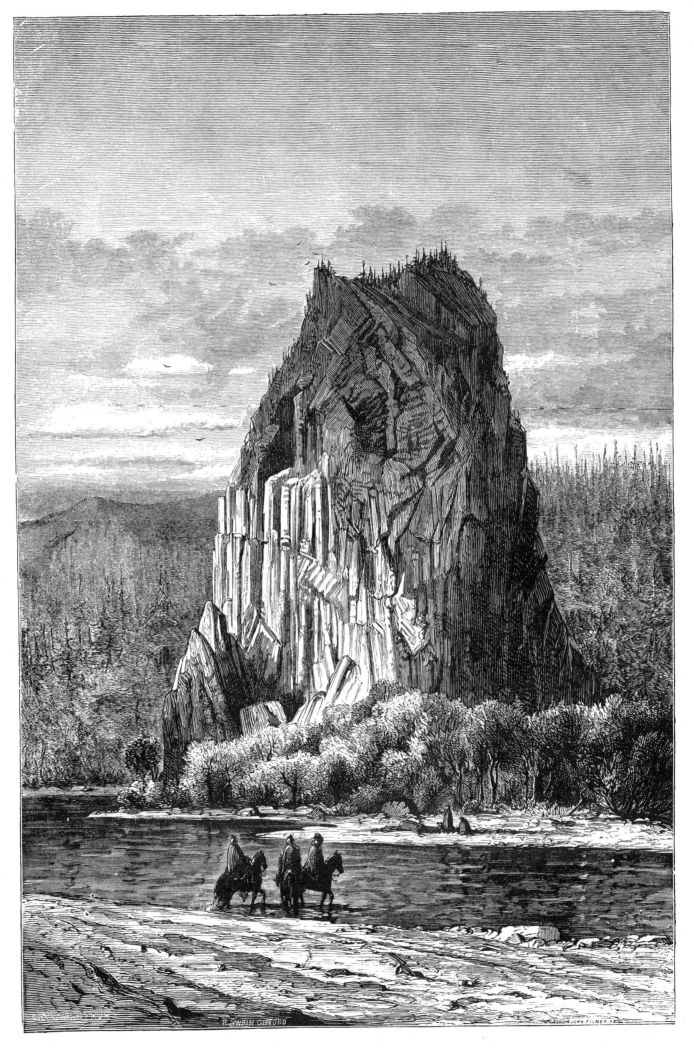

R. SWAIN GIFFORD

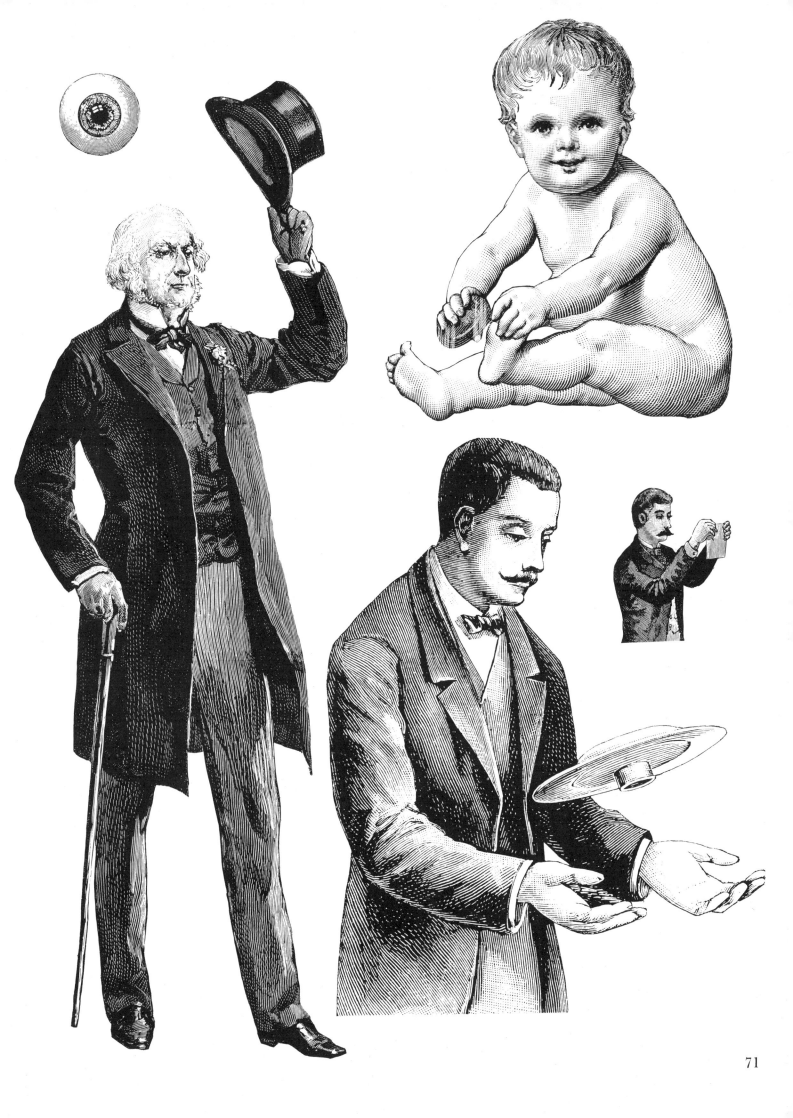

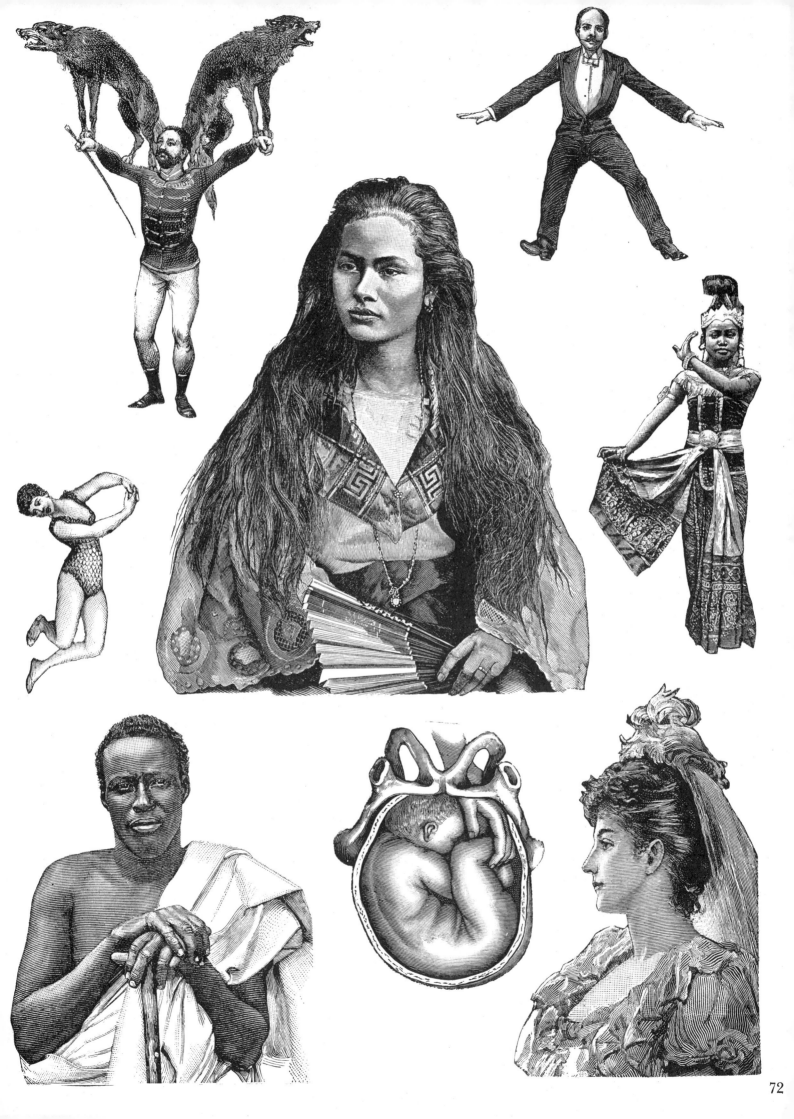

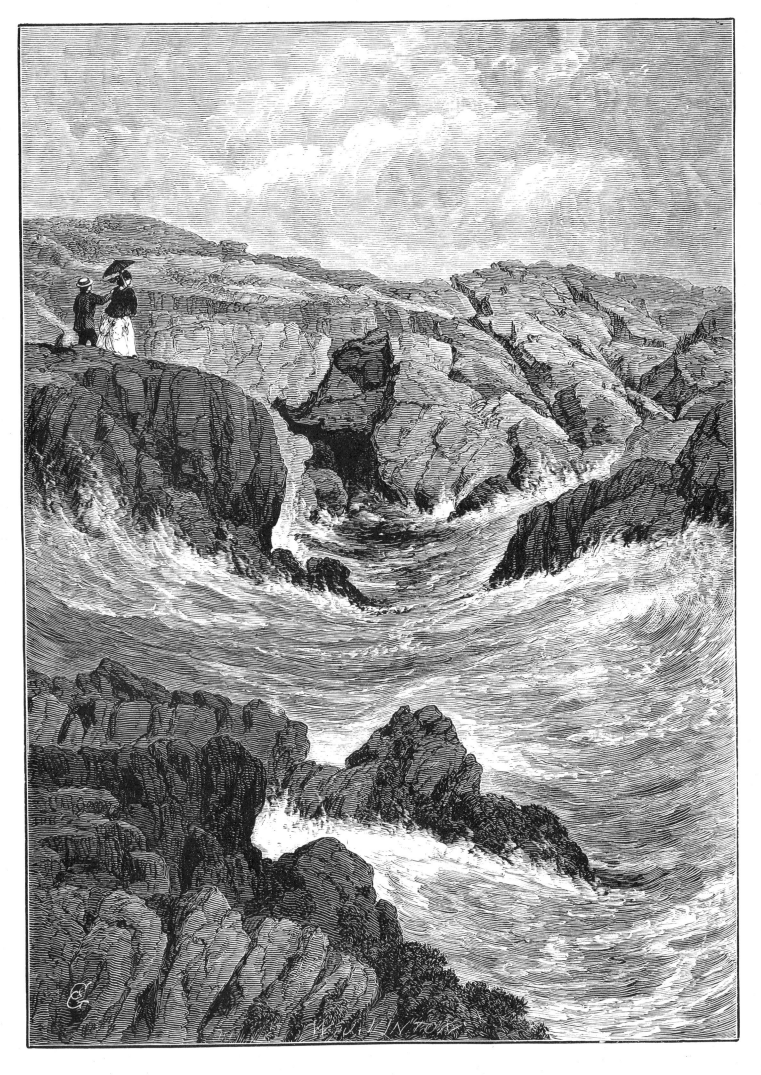

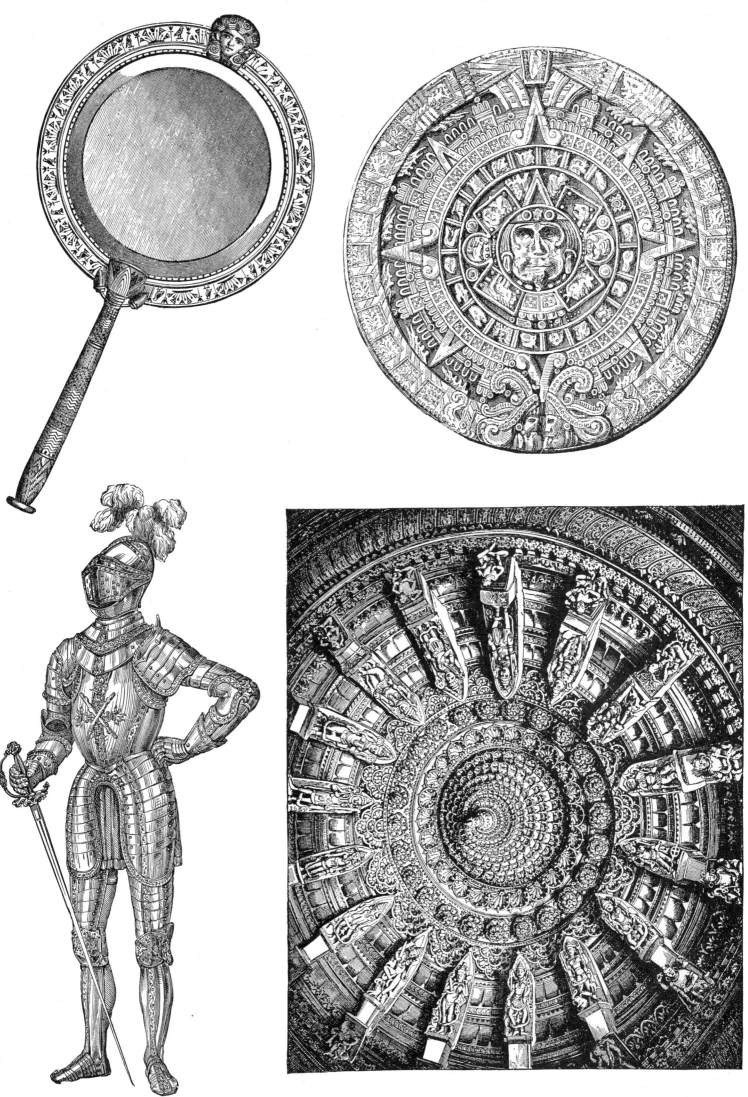

74

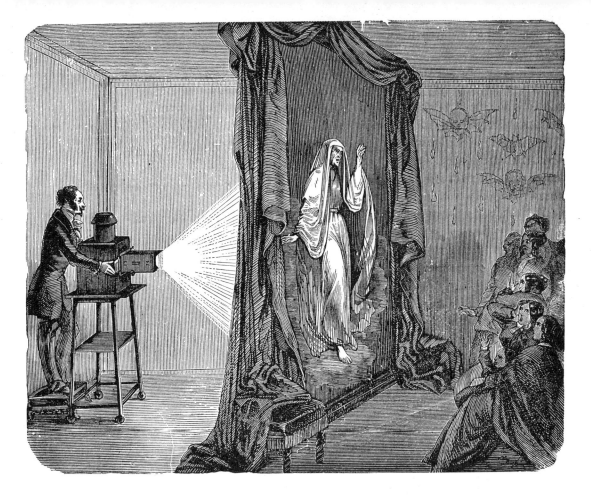

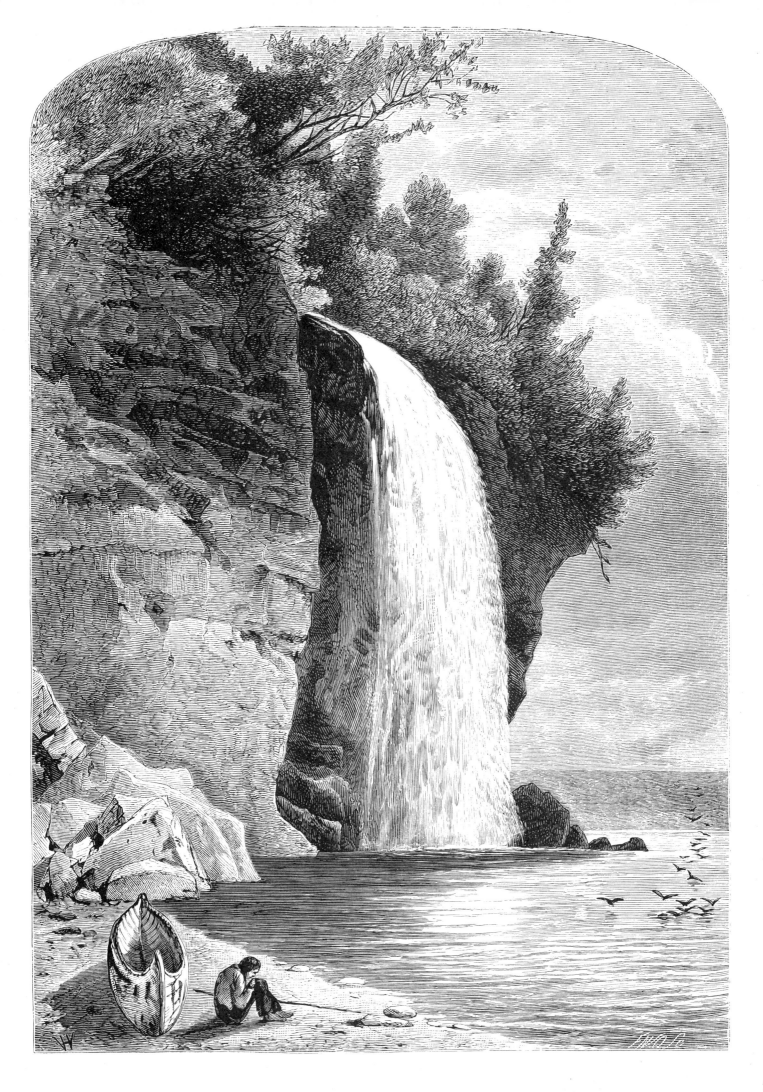

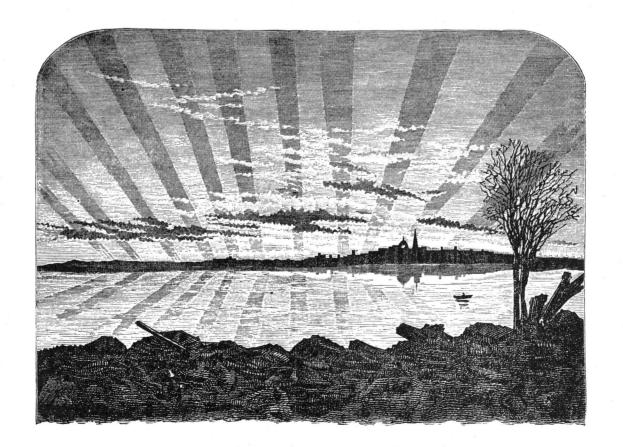

77

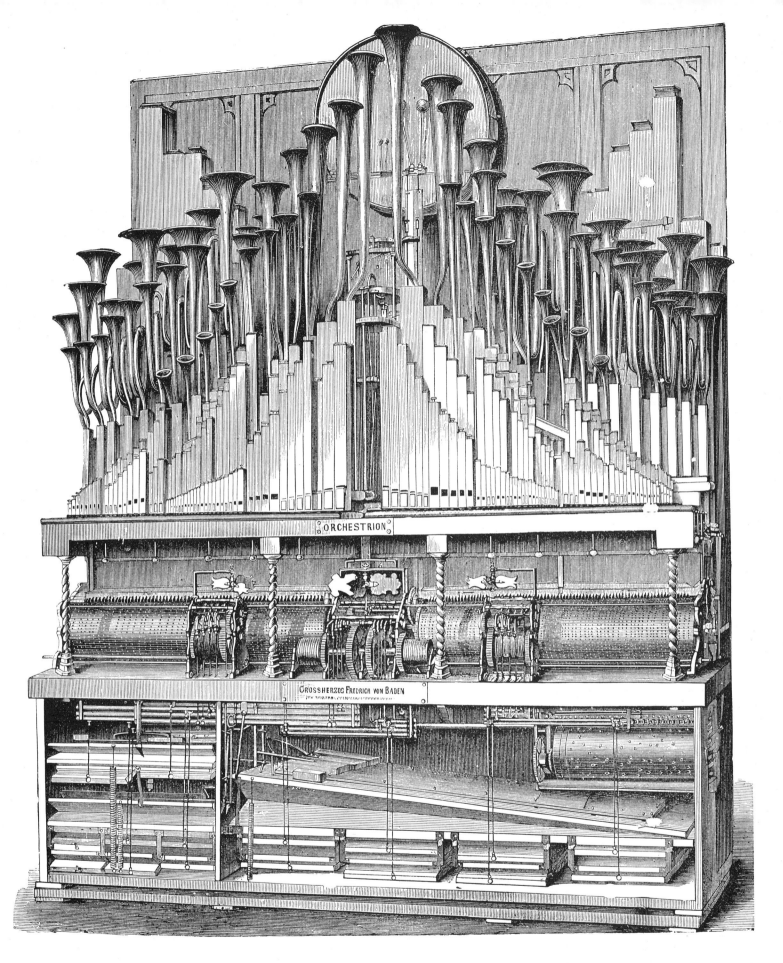

ORCHESTRION

GROSSHERZOG FREDRICH von BADEN

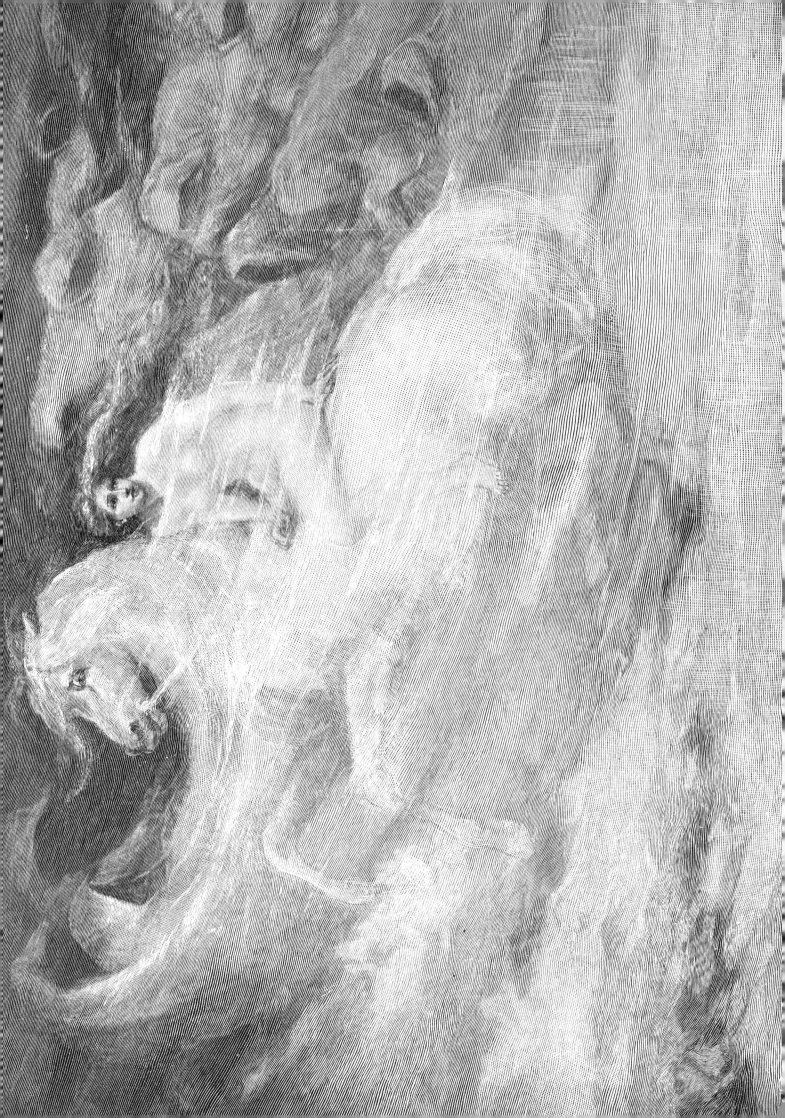

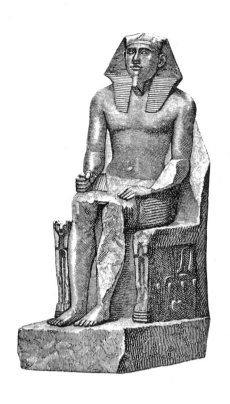

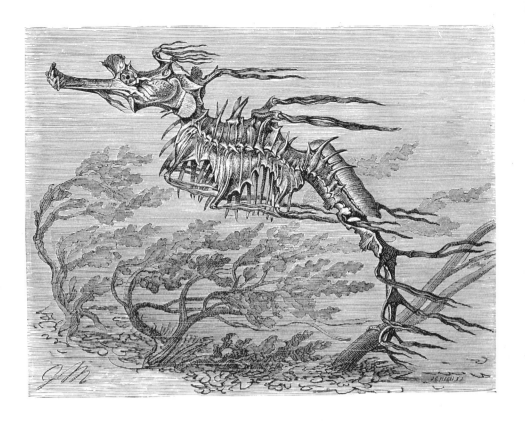

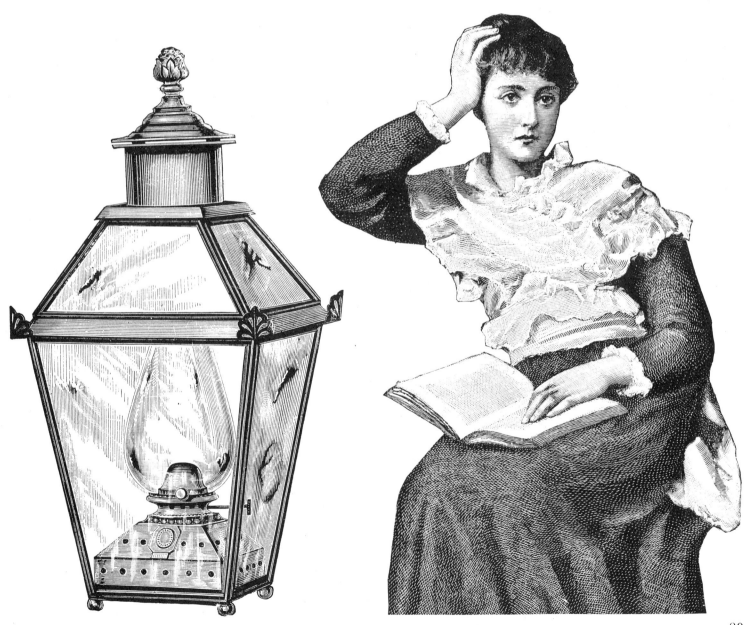

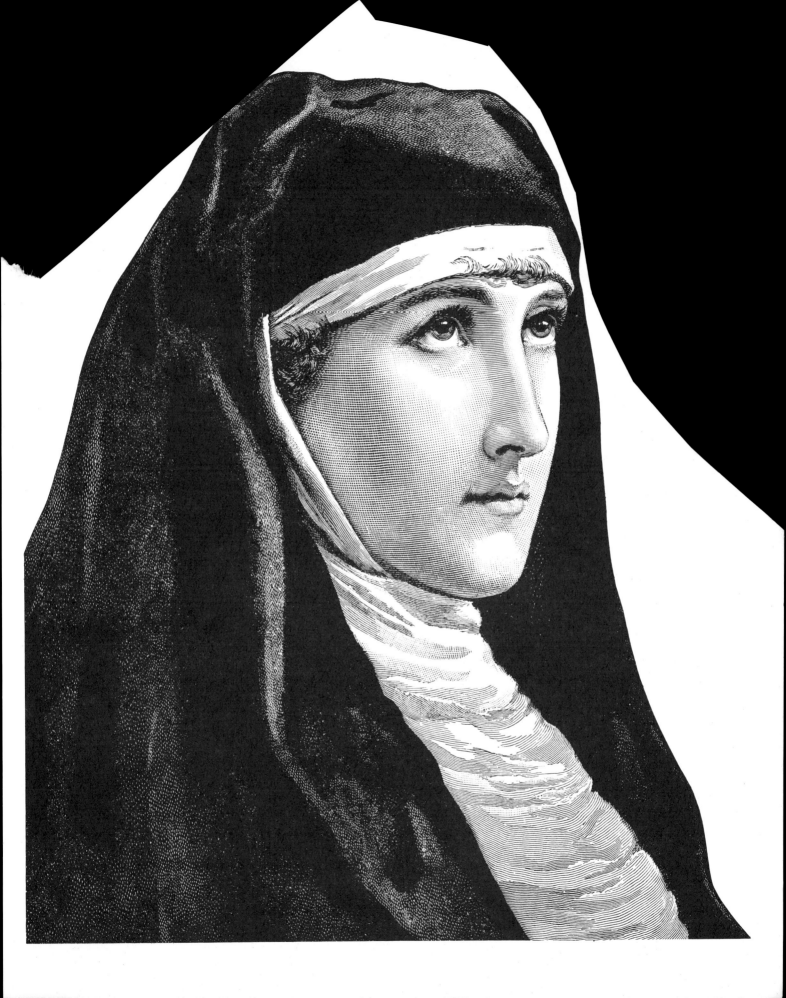

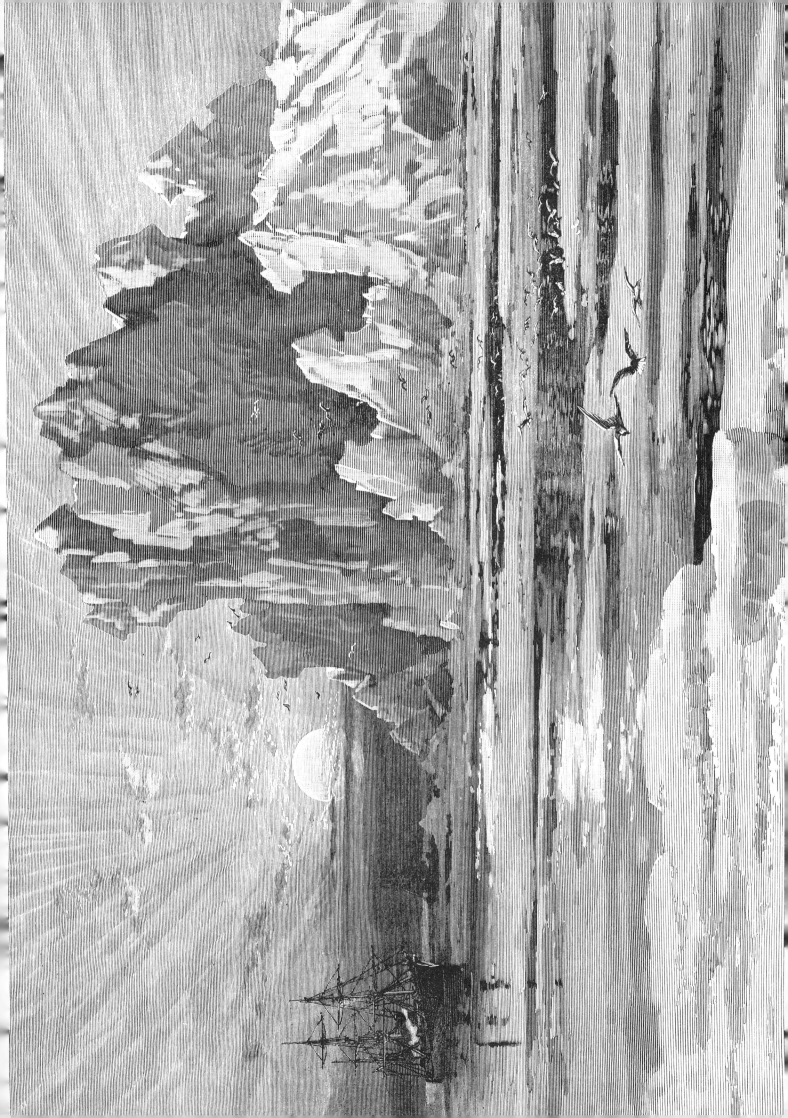

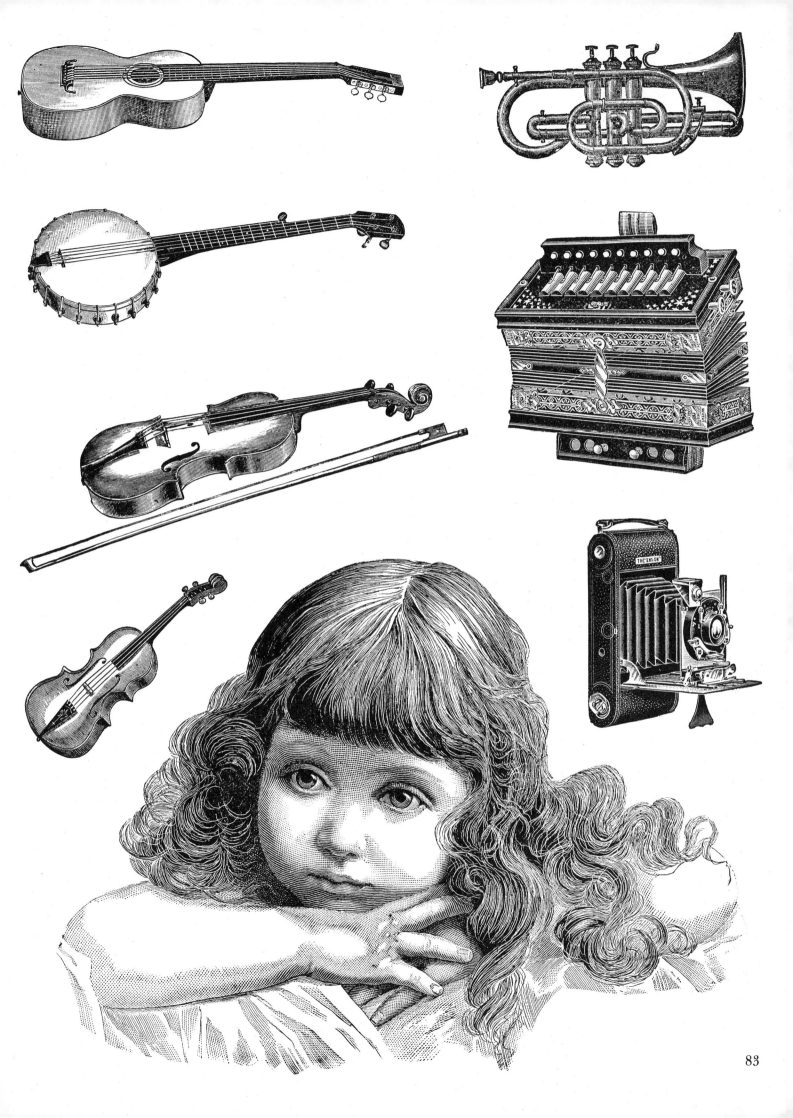

83

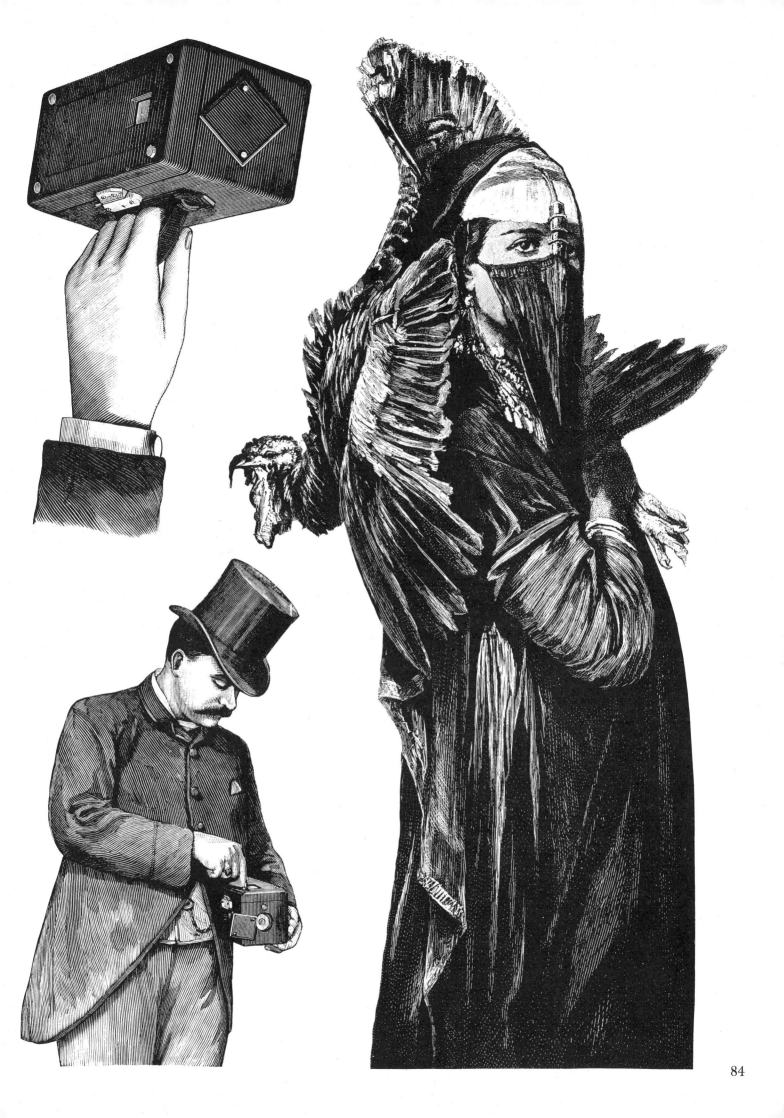

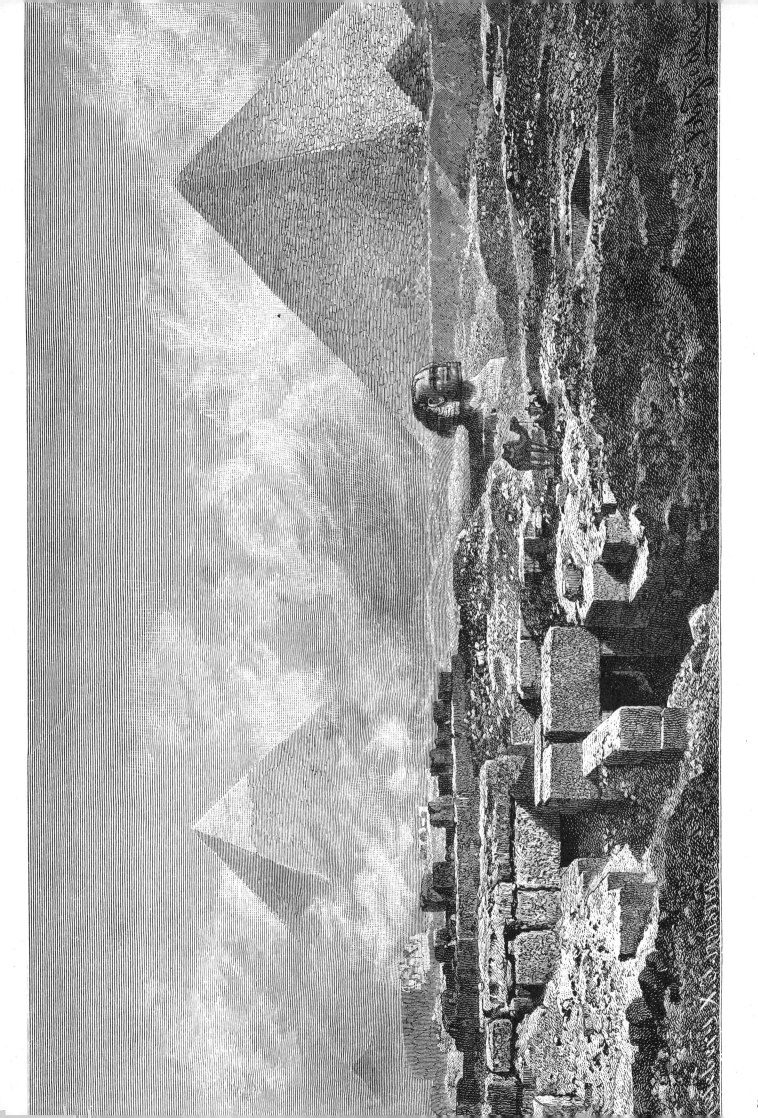

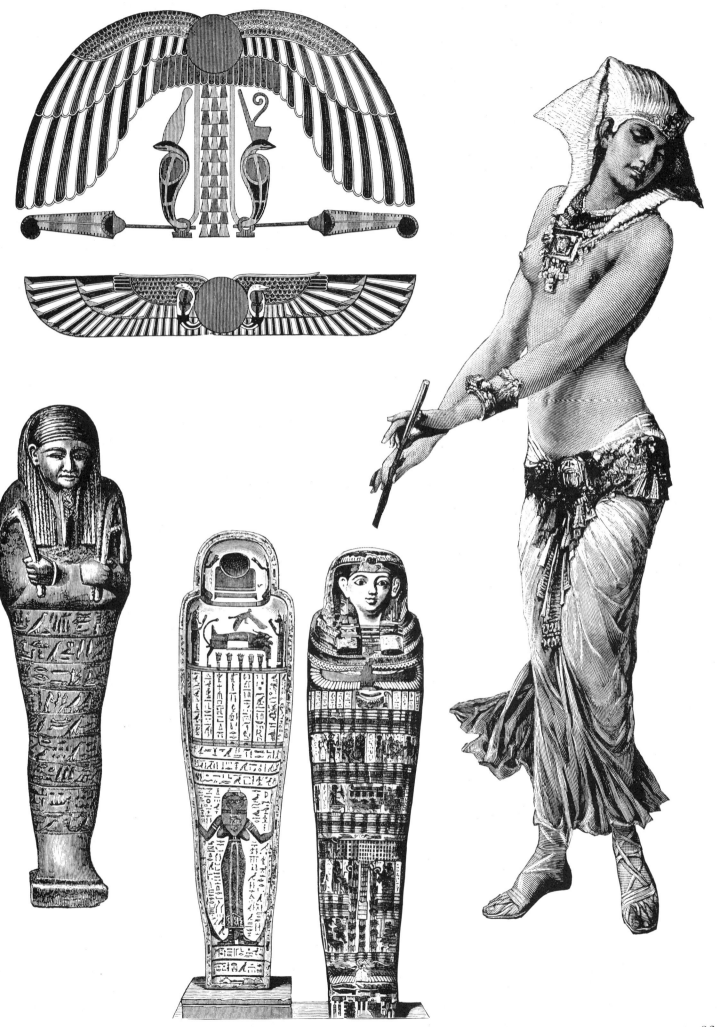

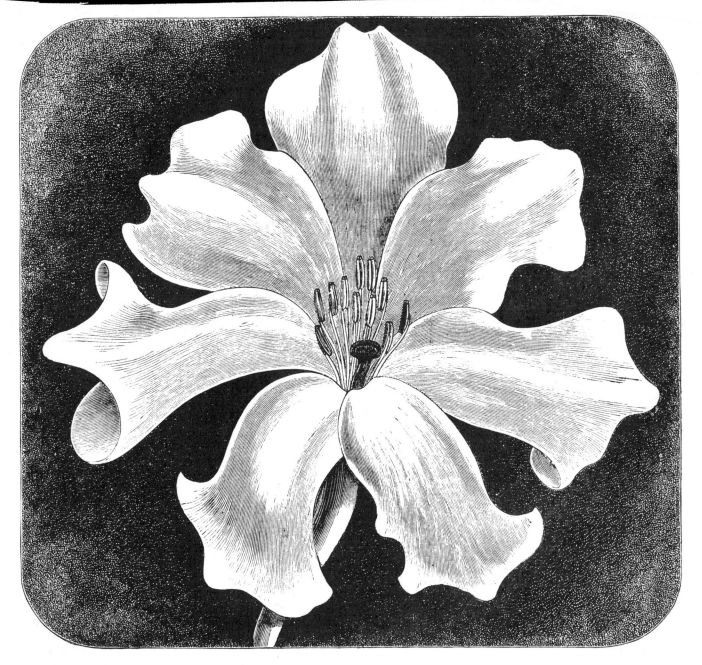

87

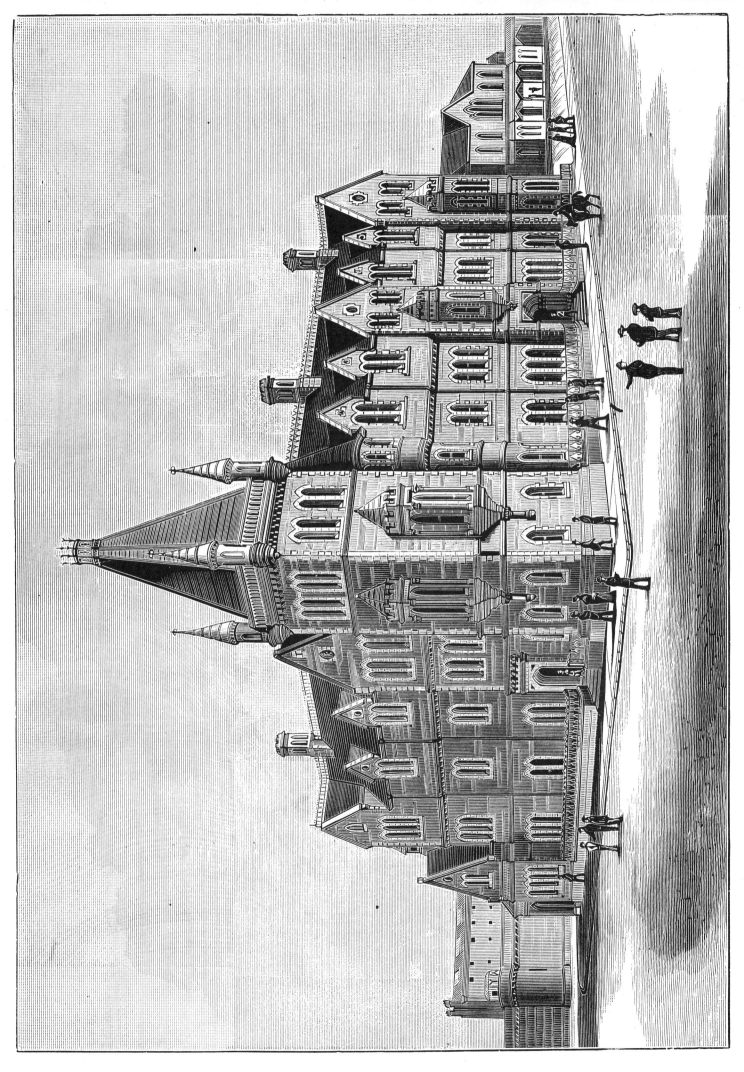

88

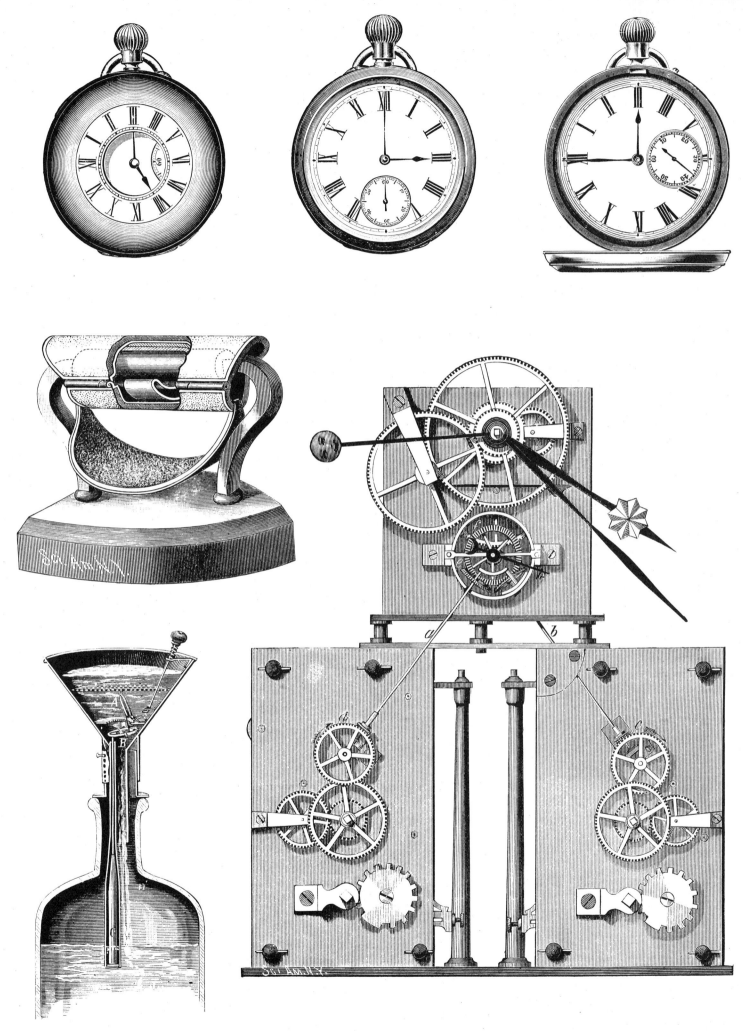

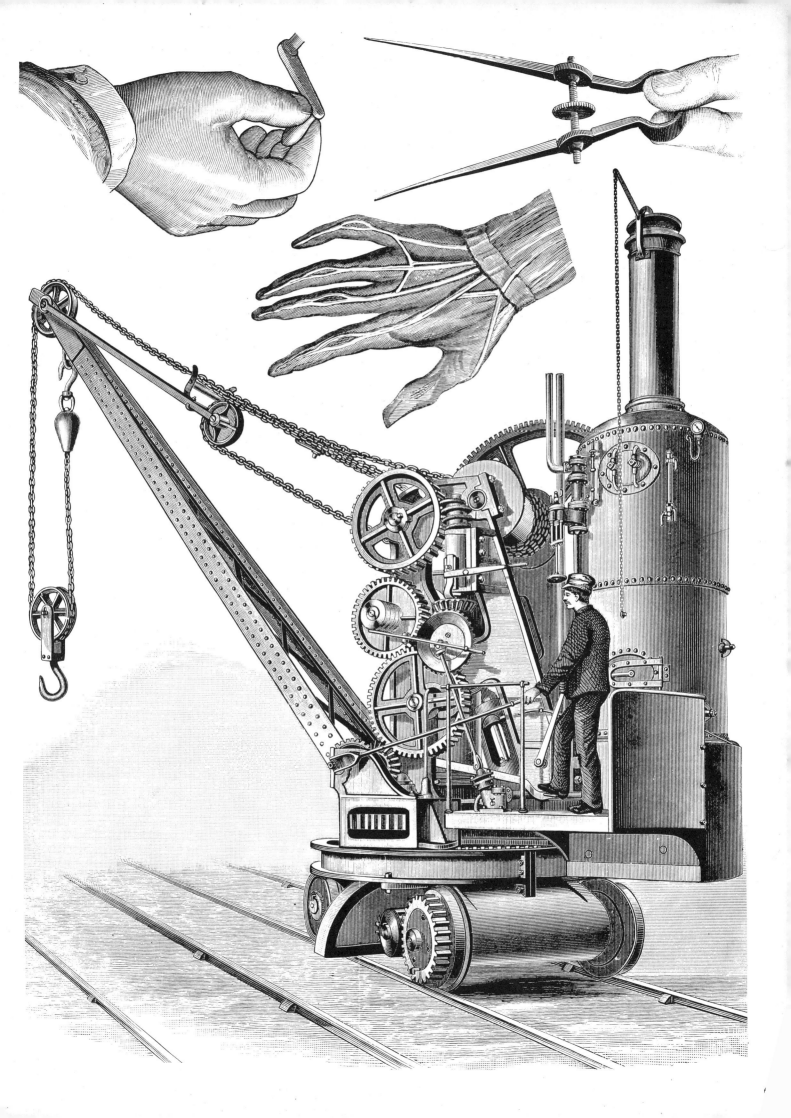